MOODS OF THE
NORTH YORK MOORS

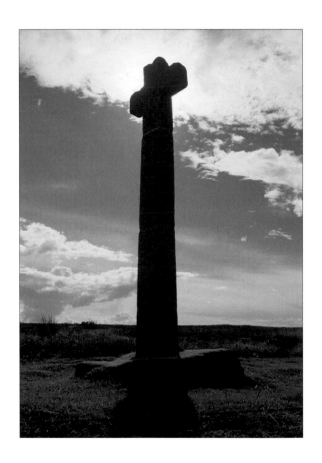

IAN CARSTAIRS

HALSGROVE

First published in Great Britain in 2003

Copyright © 2003 Ian Carstairs

Title page photograph: *Ralph Cross, symbol of the National Park.*

British Library Cataloguing-in-Publication Data
A CIP record for this title is available from the British Library

ISBN 1 84114 269 7

HALSGROVE
Halsgrove House
Lower Moor Way
Tiverton, Devon EX16 6SS
T: 01884 243242
F: 01884 243325

sales@halsgrove.com
www.halsgrove.com

Printed and bound in Spain

INTRODUCTION

The North York Moors is a relatively uncomplicated, double-decker landscape, with deep green valleys below and dark moors above, terminated abruptly at the North Sea. Its geology is equally simple: shales laid down under an ocean 200 million years ago form the bottom of the valleys and, above them, sandstones which owe their origins to a vast river delta. On top of them across the south of the National Park are other layers, mostly limestones, again laid down under a primaeval sea.

Pushed up by movements in the earth's crust in Jurassic times and eroded over millions of years by water, waves and wind, this mass of land stretching from near Saltburn to Scarborough, along the edge of the Vale of Pickering and with a steep escarpment to the Vale of York, is one of England's most clearly-defined landscapes.

For me, the moods of the moor are far more than the varying play of light on the shape of the land, spectacular as this may be. My moods are also driven by the emotions, reflections and ideas evoked not only by the natural features and the changing light, but also by the evidence of the people who have lived here, and the profound issues which face us all if this living, working landscape is to thrive and be sustained into the future.

On a micro-scale I am saddened to know that the corn buttercup is almost extinct in Yorkshire. Then, I am excited that a local naturalist has discovered one; and I am simply over-the-moon that seeds from the plant have been propagated at the Ryedale Folk Museum and reintroduced to an experimental arable field near Silpho.

At the other extreme, I am awestruck that England's 'Grand Canyon' – Newtondale – could have been carved out in just a few decades by meltwaters at the end of the Ice Age. I am filled with nostalgia to watch the steam trains at Levisham station in the valley bottom, fondly remembering that ghostly last train of the movies. But, paradoxically perhaps for a conservationist, my strongest recollection of this beautiful valley is the indelible memory of the sheer, unearthly exhilaration from flying along it and round its bends in an RAF jet at several hundred miles an hour.

On a more spiritual note, there is nothing to compare with the timeless quiet of the thousand-year-old crypt beneath Lastingham church. And while I delight at the traditional farming and land management on which the moors depend, I am profoundly fearful for the future of the upland farmers, without whom the moors would be a very different place indeed.

My photographs are therefore a tool, a springboard, I hope, to understanding, enjoying and sharing the story of the North York Moors and its wildlife. Without photographs, appreciating the complexity of any landscape for many of us would be much more difficult. The images and comments are of course mine. The reactions to them, the nerves they touch in the imagination, the moods and memories they might evoke and the desires to experience the intimacies of this marvellous place yourself, will of course be uniquely your own.

Ian Carstairs
2003

LOCATION MAP

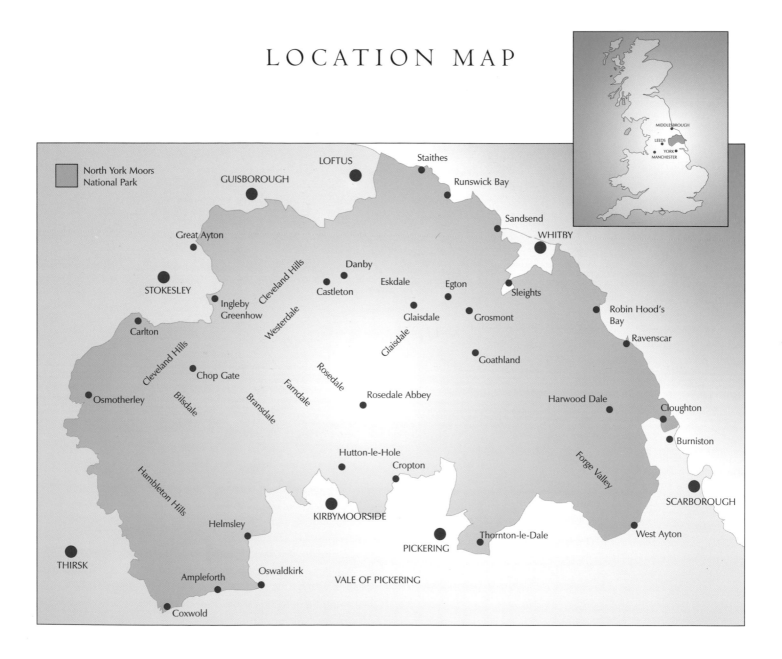

North York Moors
National Park

LOFTUS

Staithes

GUISBOROUGH

Runswick Bay

Sandsend

WHITBY

Great Ayton

Danby

Eskdale

Egton

STOKESLEY

Castleton

Sleights

Ingleby
Greenhow

Cleveland Hills

Westerdale

Glaisdale

Grosmont

Robin Hood's
Bay

Carlton

Glaisdale

Ravenscar

Cleveland Hills

Chop Gate

Rosedale

Goathland

Osmotherley

Bilsdale

Farndale

Rosedale Abbey

Harwood Dale

Cloughton

Bransdale

Burniston

Hutton-le-Hole

Hambleton Hills

Cropton

Forge Valley

SCARBOROUGH

Helmsley

KIRBYMOORSIDE

Thornton-le-Dale

West Ayton

THIRSK

PICKERING

Ampleforth

Oswaldkirk

VALE OF PICKERING

Coxwold

MIDDLESBROUGH

LEEDS

YORK

MANCHESTER

The dawn of time
Two hundred million years ago, the whole of the North York Moors lay under the sea.

Midwinter sunrise
An outrageous dawn across the south of the Park, where a huge lake known as
Pickering Lake formed at the end of the last Ice Age, about 12,000 years ago.

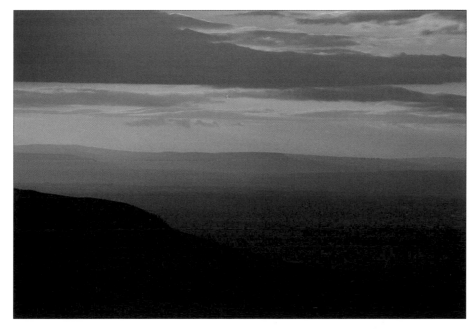

A place apart
Over millions of years the land has been assaulted by water, wind and ice, separating
the Moors from the Yorkshire Dales, which lie across the Vale of York to the west.

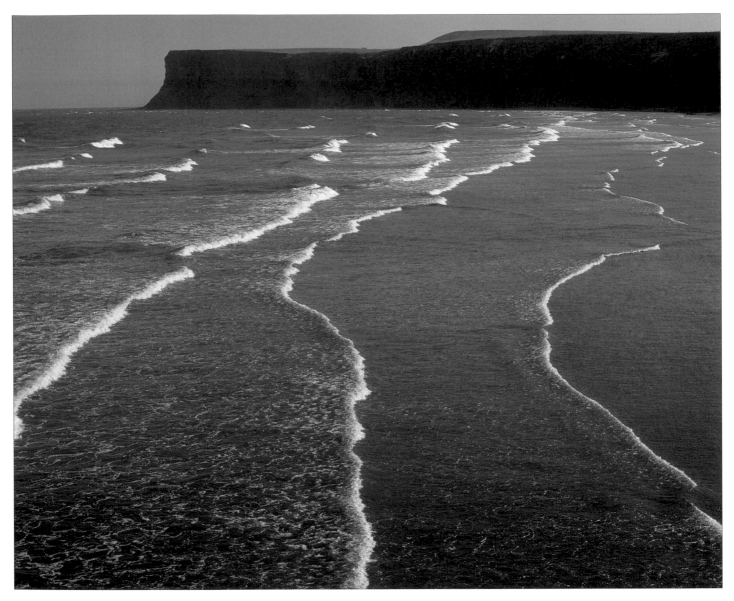

Dramatic coast

East of Saltburn, the upland block rises as perpendicular cliffs which are under constant attack from the North Sea.

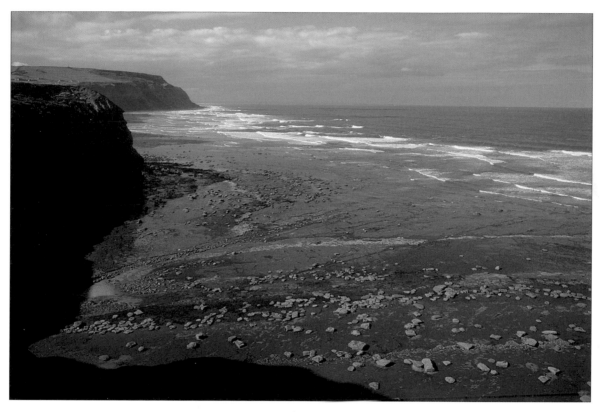

High point
Boulby Head, the highest cliffs in Eastern England (700 feet/213m), viewed from Cowbar, Staithes.

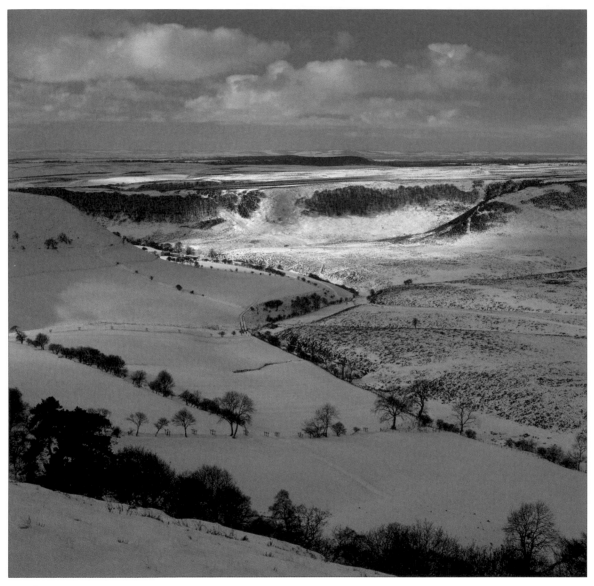

A natural amphitheatre, or ...
The vast bowl of the Hole of Horcum has been carved by springs seeping from layers in the rock.

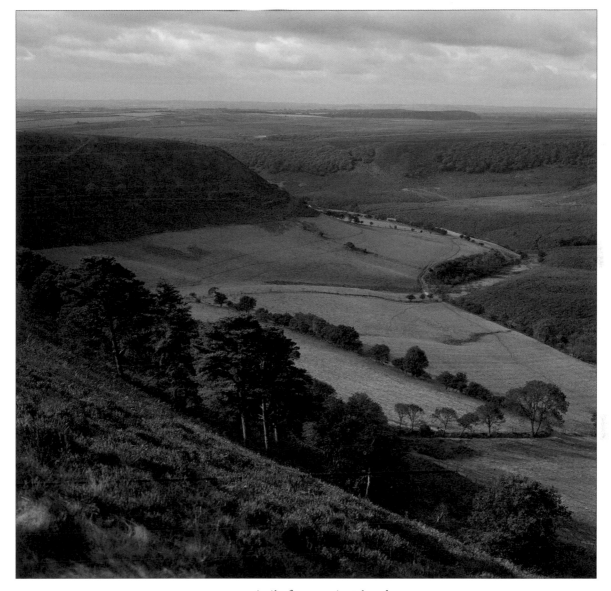

... a missile from a giant hand
But folklore tells that a giant called Wade scooped up the earth and threw it at his wife,
thus creating the huge depression.

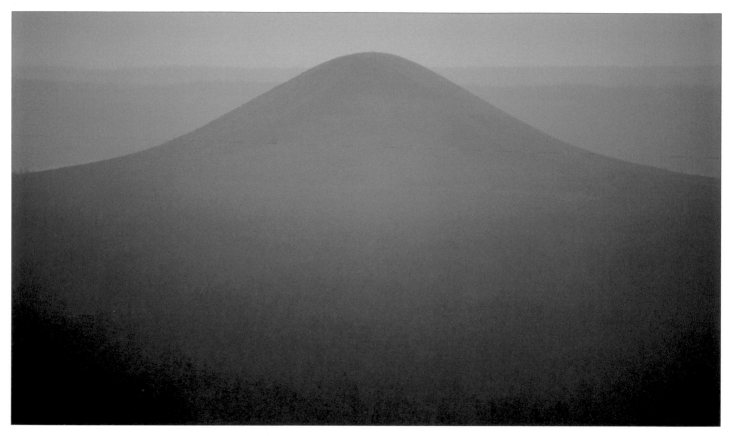

Snow storm at Blakey Topping
Blakey Topping, where the pile of earth thrown by the Giant Wade at his wife is reputed to have landed.

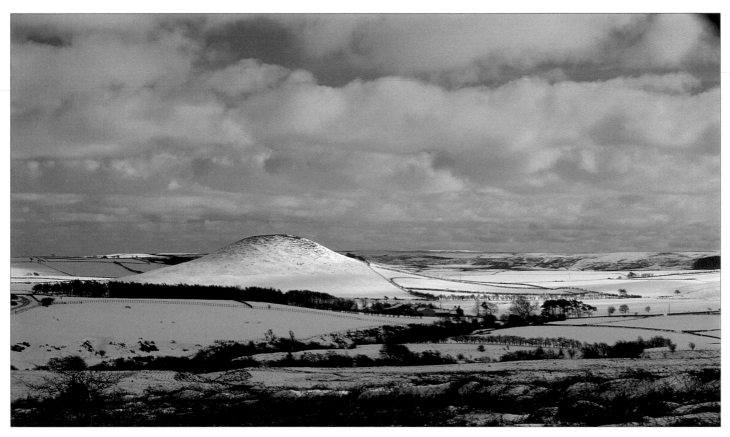

Natural or man made?
*Freebrough Hill, another contender for the resting place of Wade's misdirected pile of earth, is such a perfect
shape that people once thought it was a massive prehistoric construction.*

Top heavy
*Sculpted by frost and wind
and standing out sharply
on a fiercely cold winter's
afternoon, the Bridestones
remove any doubt that
other layers of rock once
covered the moors.*

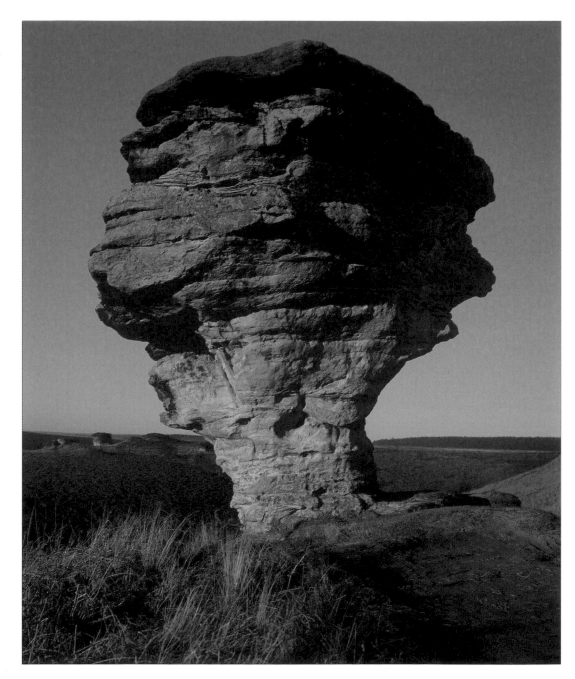

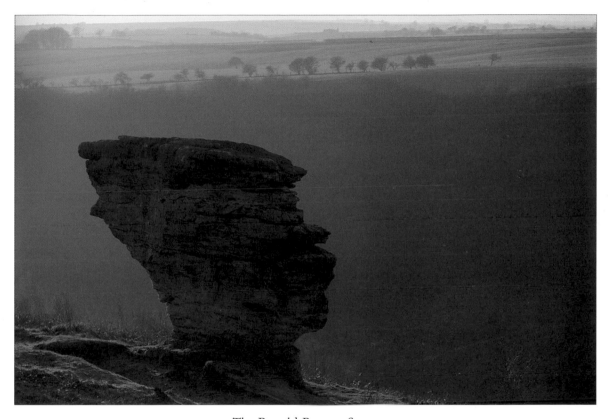

The Ronald Reagan Stone

*Some people think that from a certain angle, the silhouette of this stone closely resembles
that of the ex-President of the United States.*

Deep winter and barely light *High above Great Brougton, the Wainstones are a remote sandstone outcrop. It is an eerie place, especially when the wind moans through its crevices as it blasts across the ridge from Bilsdale.*

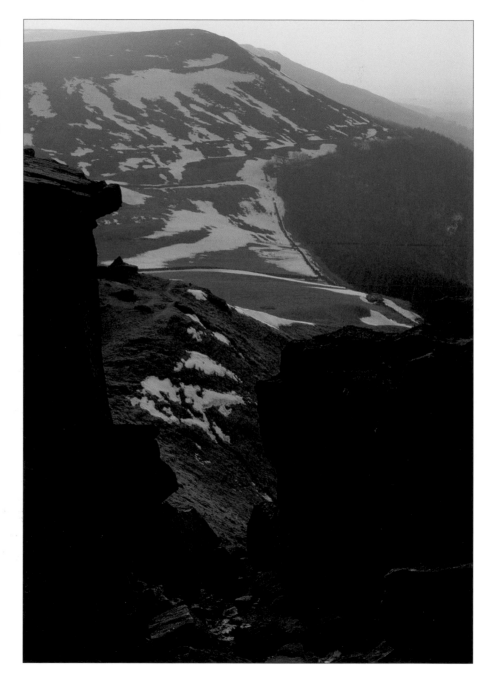

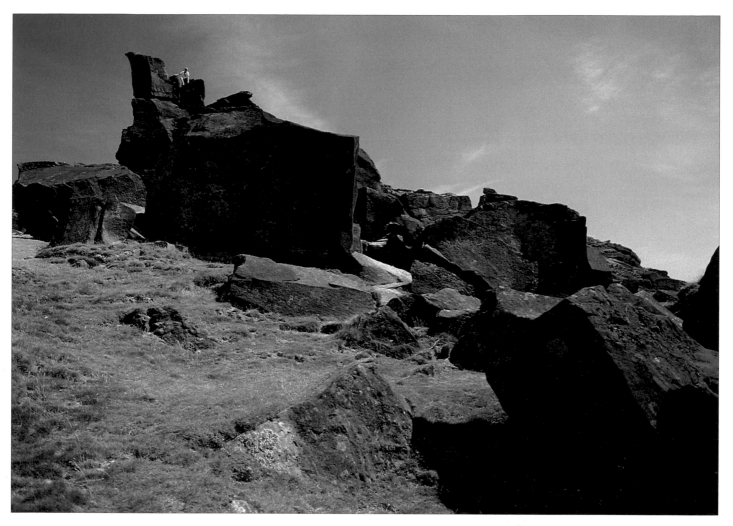

Top-of-the-world
*A rare, beautifully calm and clear hot day makes the Wainstones an unsurpassed vantage point for
the view north across the Cleveland Plain towards Middlesbrough.*

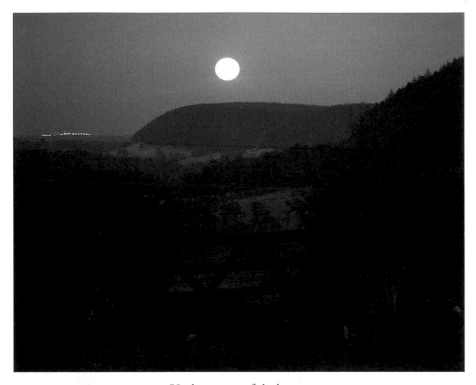

Under cover of darkness
Night time brings its own quality to the landscape, as shown in this shot of a waxy
moon rising over the Tabular Hills east of Lastingham.

Layers of limestone
The north-facing slopes of the Tabular (table-like) Hills stretching across the south of the Park mark where the limestone ends and the sandstones, on which the heather grows, begin.

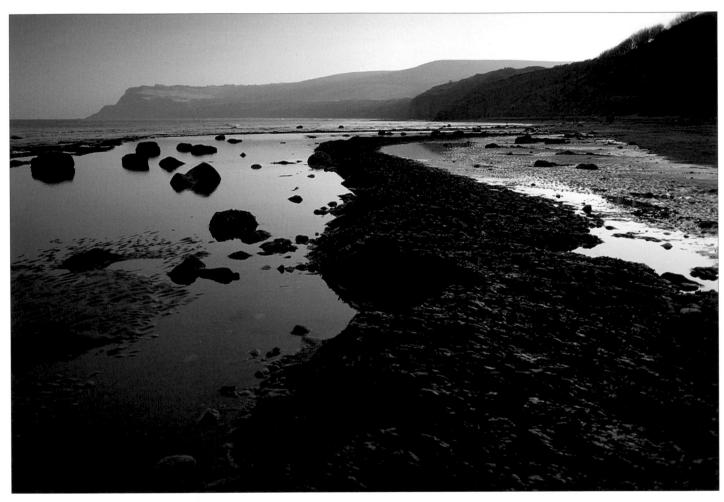

On the shore at the Bay

The ridges of hard and softer layers form wonderful rock pools in Robin Hood's Bay. The coast here is famous for its fossils.

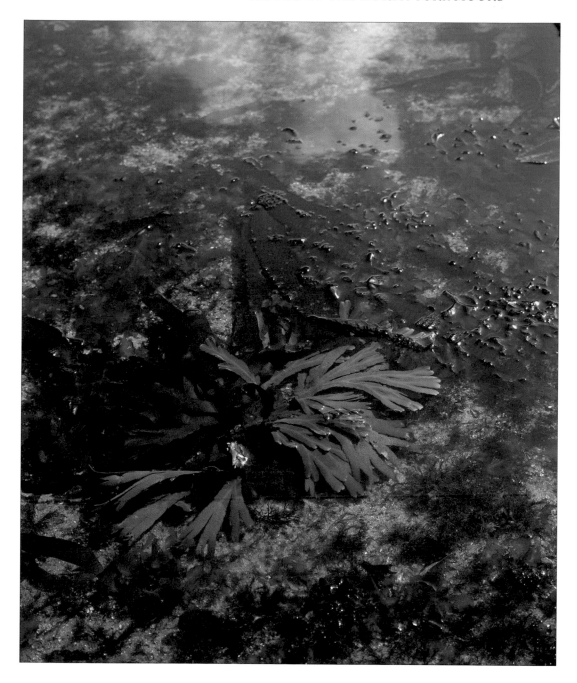

Life beneath the waves
*Marine life abounds along
the coast and can be easily
studied on rocks and in pools
at low-tide.*

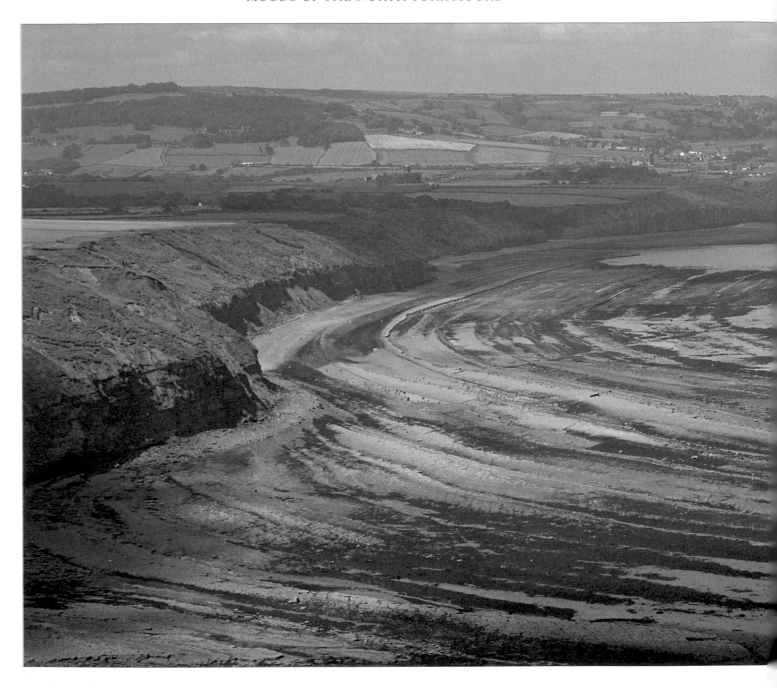

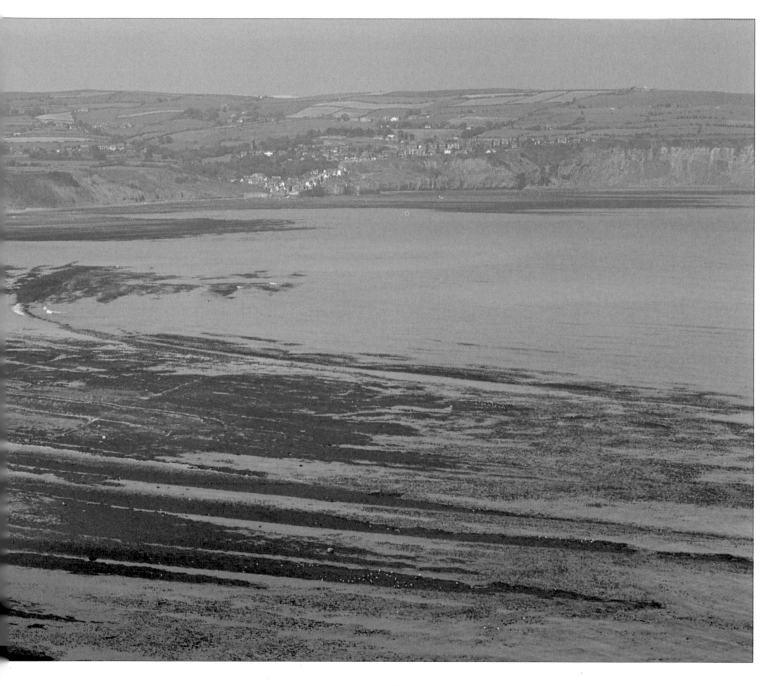

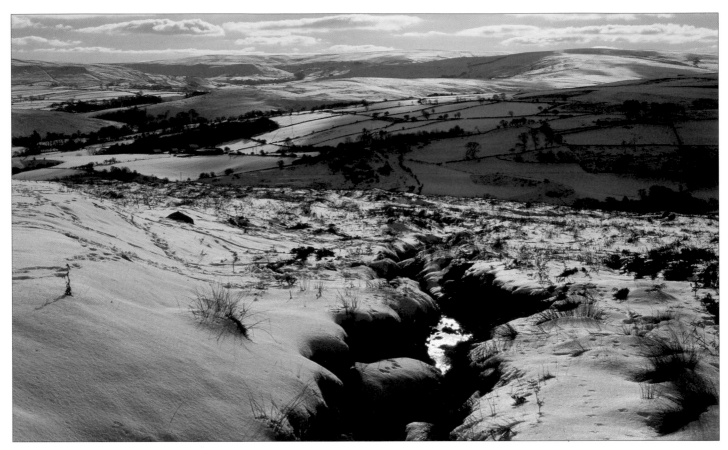

The power of water
All the deep valleys of the moors were formed by the effects of springs and streams, not by ice. Seen from across the Esk Valley,
they lie in a herringbone-pattern to north and south of the central highest ridge.

Previous pages: Equinox
A very low September tide reveals in graphic detail the full extent of the shape of Robin Hood's Bay,
like a slice across a huge half-submerged onion.

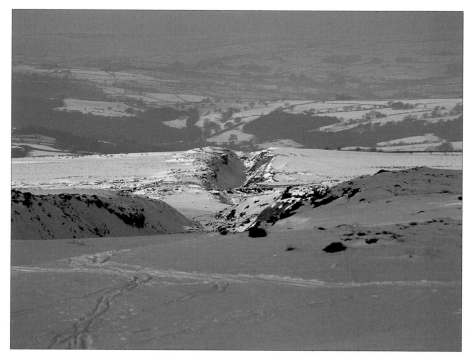

A fiery finger near Fylingdales
About 58 million years ago a narrow finger of molten rock thrust its
way across the land. You can easily trace its route where the hard
rock has been mined and quarried in the past.

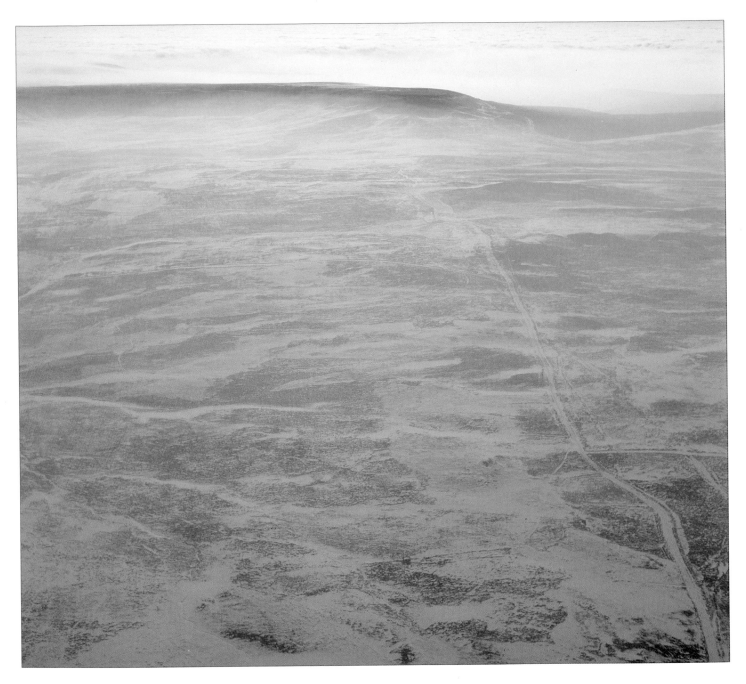

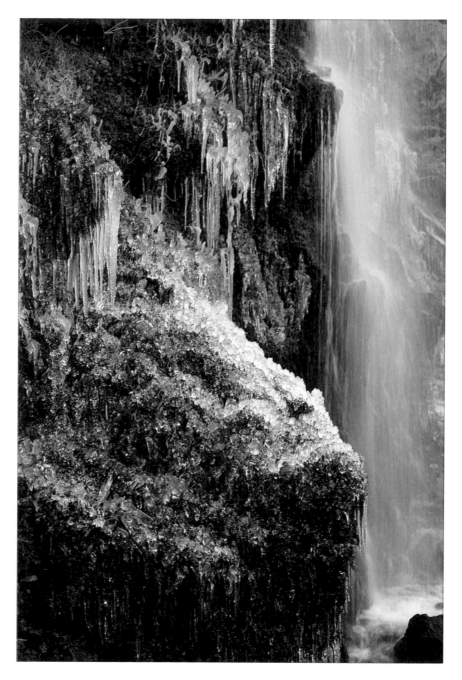

The temperature rises
*About 15,000 years ago
the climate warmed,
the ice retreated and vast
amounts of water were
released. Malyan Spout on
a winter's day.*

Opposite: Mists of time
*During the last Ice Age
ice sheets surrounded the moors
on three sides. Fog in the
Vale of York gives an
impression of what it might
have looked like.*

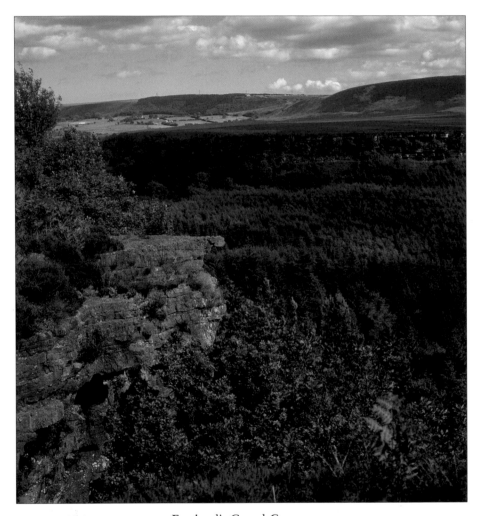

England's Grand Canyon

Meltwater cascading southwards gouged the huge gorge called Newtondale, once dubbed 'England's Grand Canyon', at its most dramatic near Needle Point.

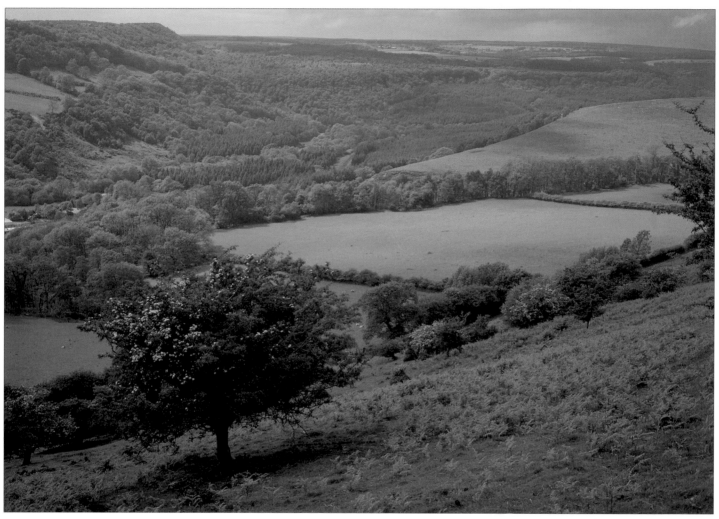

A staggering effect

Approached from Levisham, the enormity of Newtondale comes as a complete surprise as the road drops into the valley.

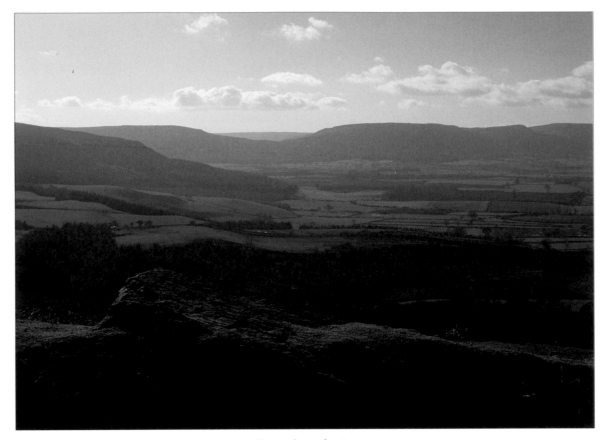

Ground out by ice

Ice grinding against the Cleveland Hills helped to sculpt their characteristic and slightly menacing north faces.

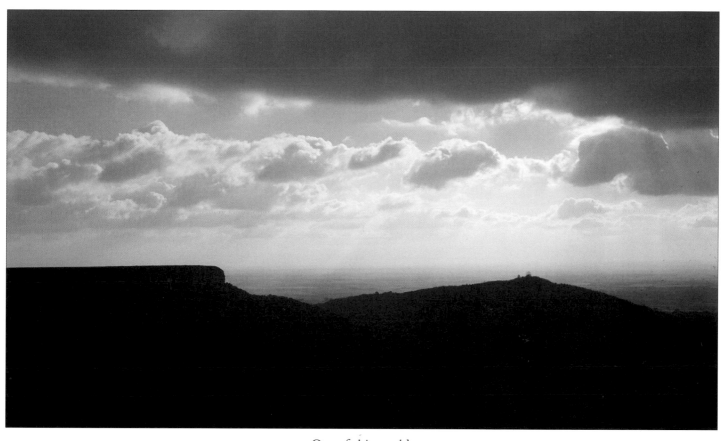

Out of this world

Many people arrive in the moors up the notoriously steep Sutton Bank. From the top it is as if you have left one world and entered another – the world of the North York Moors.

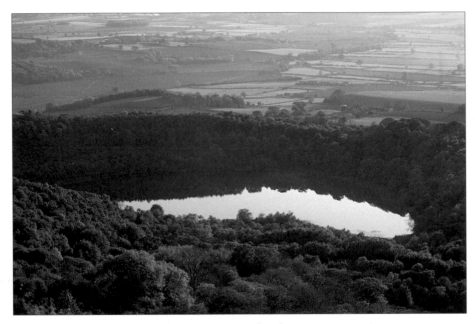

Mysterious depths
Lake Gormire, formed in a blocked meltwater channel at the end of the Ice Age,
is the only large natural lake in the moors.

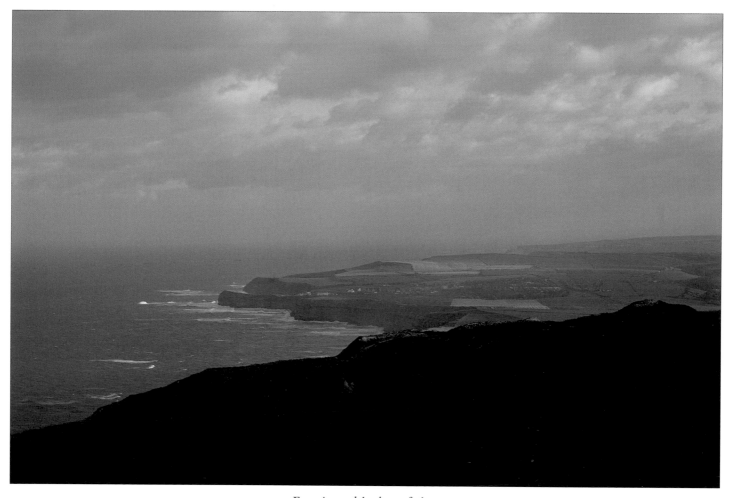

Farming a blanket of clay

The ice sheets advanced a little way inland leaving vast quantities of boulder clay when they melted. Farming along the coastal strip, including here near Staithes, coincides largely with the area once covered by the ice.

Prehistoric Des. Res.

Stunned Victorians found the remains of rhinoceros, woolly mammoth, hippopotamus, tiger and many other animals in Kirkdale Cave, once the den of hyenas more than 100,000 years ago.

The trees advance...
Once the ice had gone,
vegetation gradually
recolonised the moors until
mixed woodland covered all
but the highest ground, which
may have remained
as open grassland.

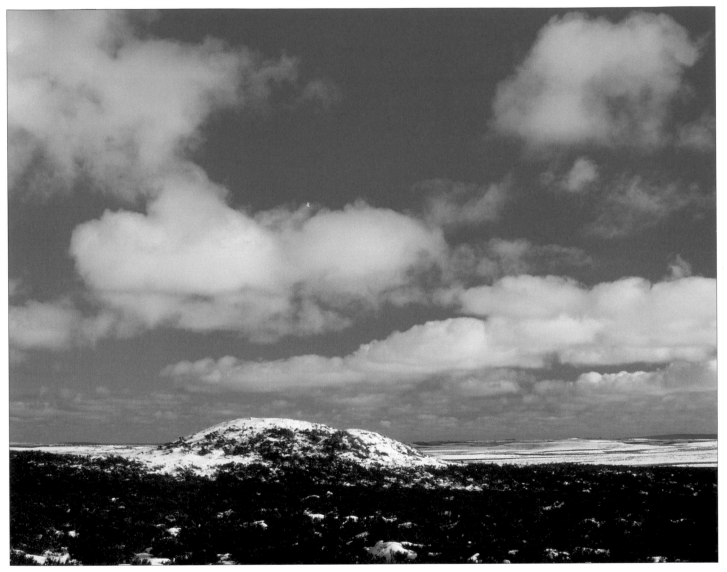

The hand of humans

By the Bronze Age, about 3000 years ago, people had colonised the moors, cleared the trees and were farming the land.
Important people were buried under mounds known as barrows, howes or tumuli, such as Robin Hood's Butts.

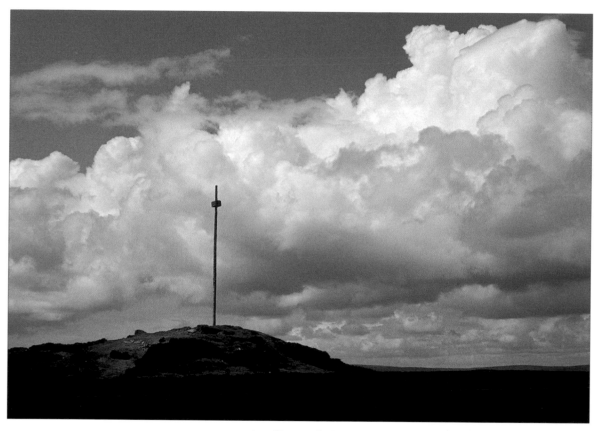

An all-round view

A phenomenal 360 degree panoramic view is to be gained from Danby Beacon,
where a burial mound is located at the highest point.

Tribal markers?
Ditches may have been used to mark boundaries in prehistoric times,
perhaps between tribal areas.

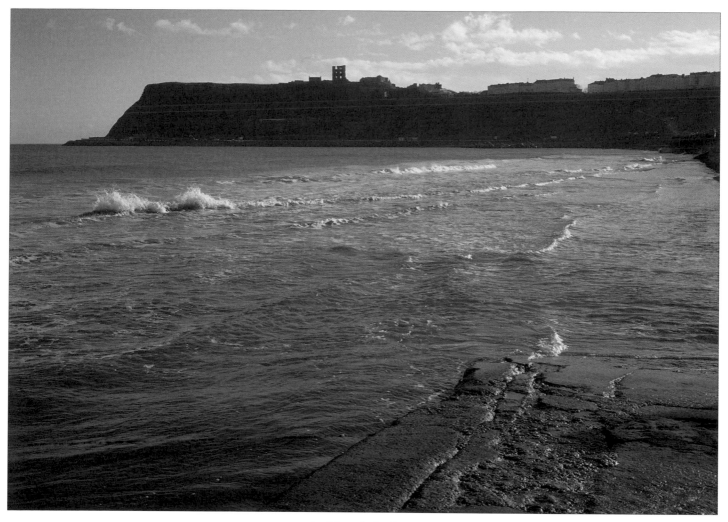

An historic lookout
Since the Bronze Age, Scarborough Castle rock, jutting into the North Sea, has provided an ideal lookout.

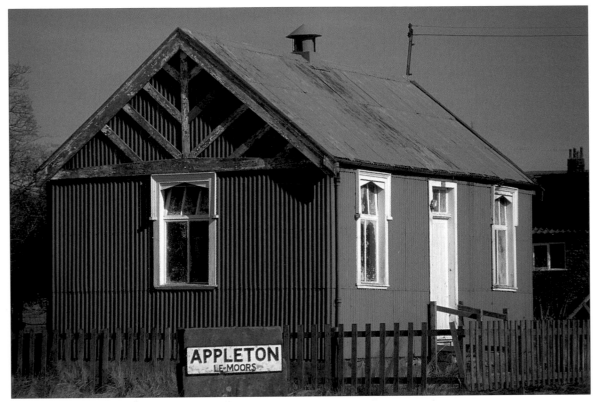

What's in a name?
Many place names give clues to their origins. Endings such as -ton, -ley, -ing and -ham are Anglian,
whereas -by or -thorpe usually indicate Viking settlements.

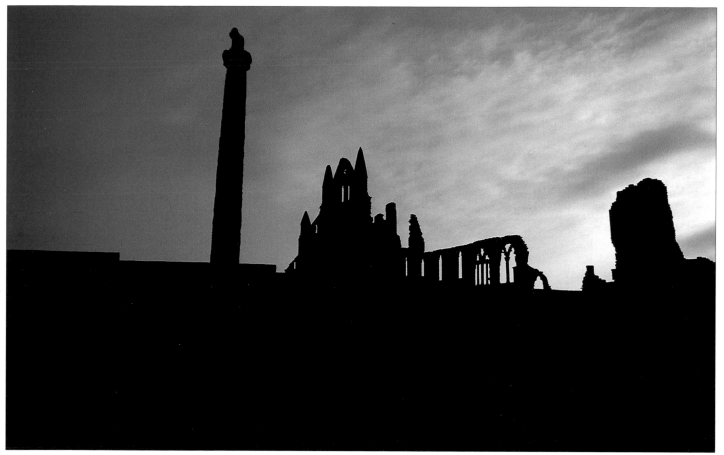

The date of Easter this year is ...

In 664AD at St Hilda's Celtic monastery on the windswept clifftop, the Synod of Whitby established how the date of Easter was to be set.

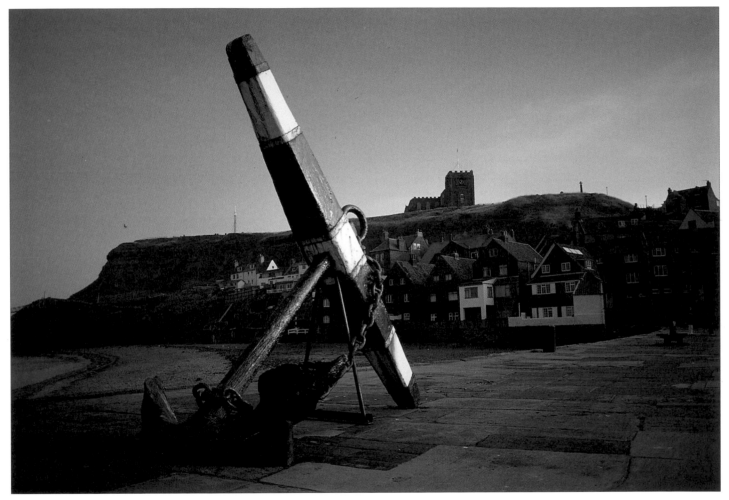

From Vikings to Cook and Dracula
Whitby, orginally a great Viking port, then departure point for Captain James Cook on his voyage of exploration and where Dracula came ashore as a dog in Bram Stoker's melodramatic novel, lies just outside the National Park.

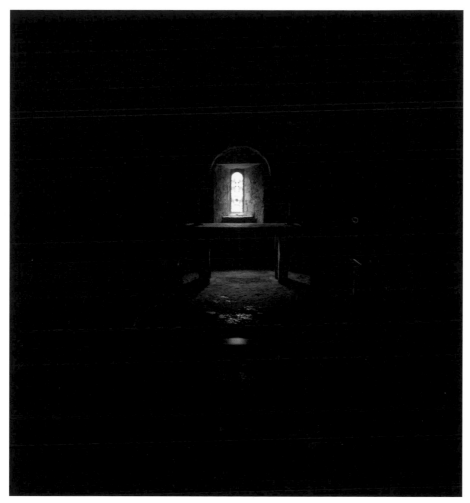

Pure peace

The altar stone in the eleventh century Saxon Crypt at Lastingham is thought to be from the earlier Celtic monastery which stood here. The silence of 1000 years in the crypt cannot be described, it can only be experienced.

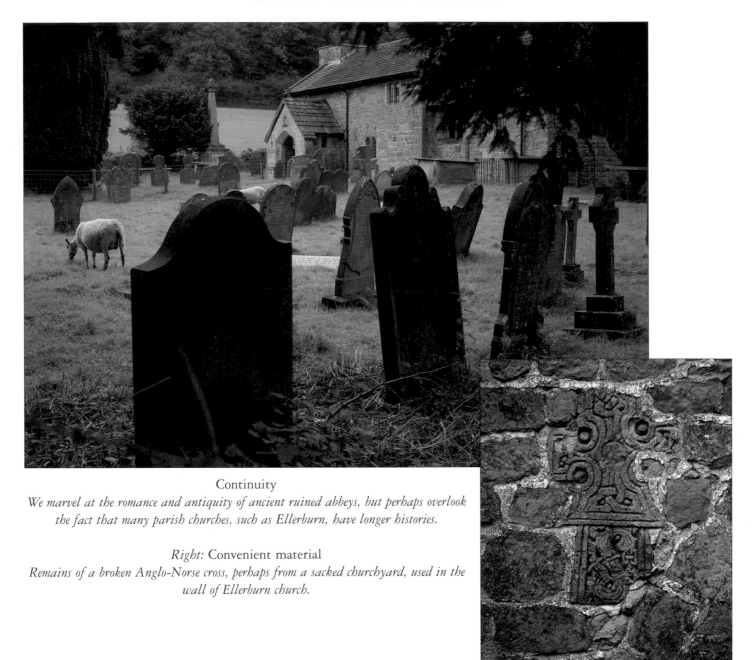

Continuity

We marvel at the romance and antiquity of ancient ruined abbeys, but perhaps overlook the fact that many parish churches, such as Ellerburn, have longer histories.

Right: Convenient material

Remains of a broken Anglo-Norse cross, perhaps from a sacked churchyard, used in the wall of Ellerburn church.

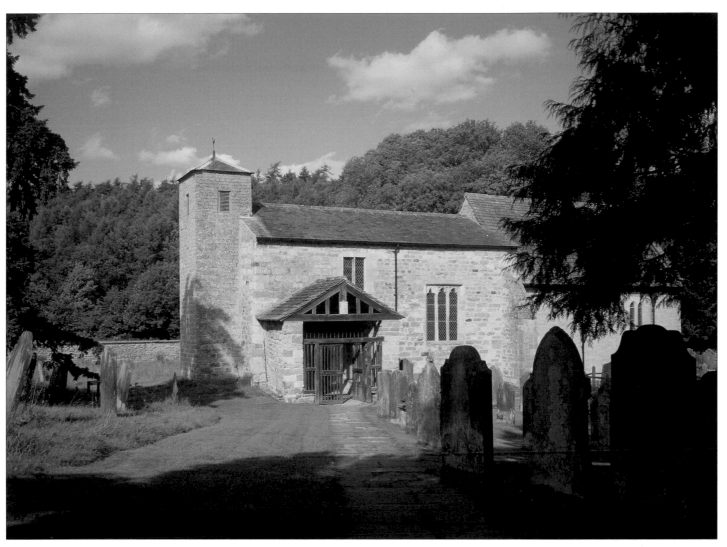

Simply idyllic
A unique Saxon sundial above the door places St Gregory's Minster, Kirkdale high among the significant churches of the Park, if not the country.

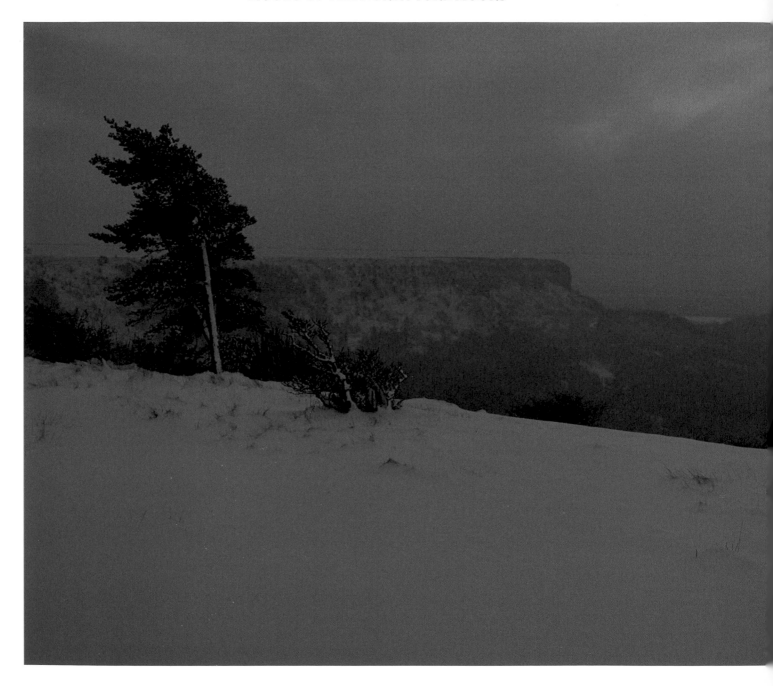

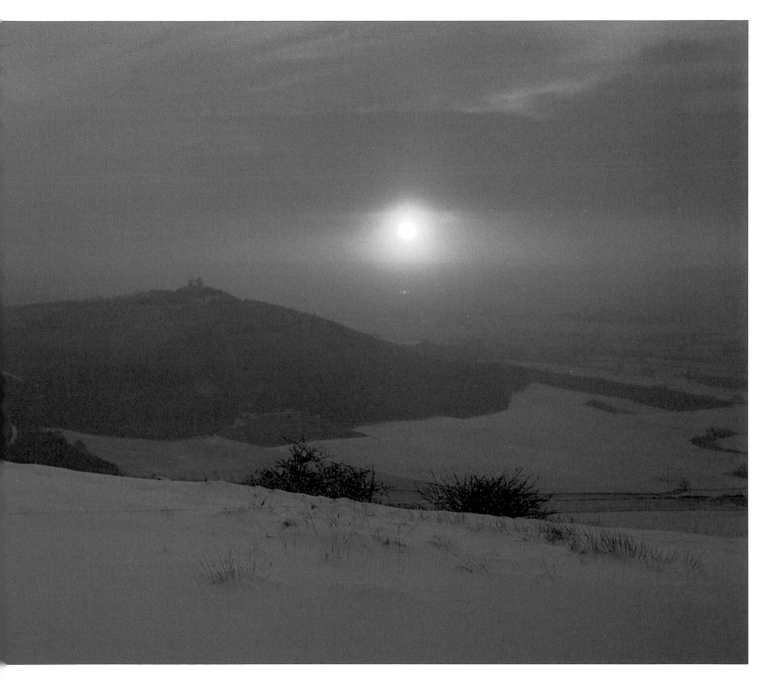

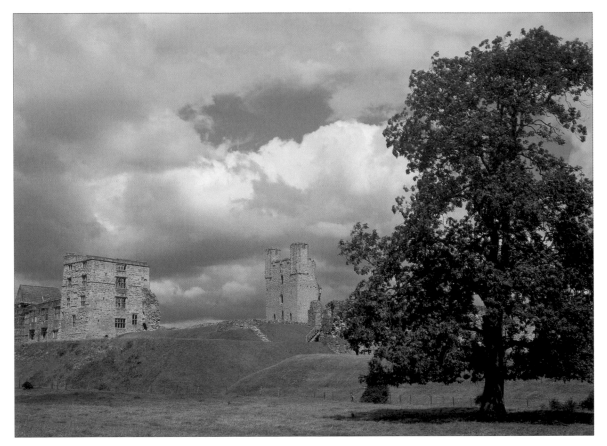

Stone replaces wood
At Helmsley, stone replaced wood as the material of castle design,
and complex solid defensive walls were also constructed.

Previous pages: The castle arrives
In 1066 the Normans arrived and with them came the castle. One such wooden castle
might have stood on Hood Hill, a commanding location on the approach to Sutton Bank.

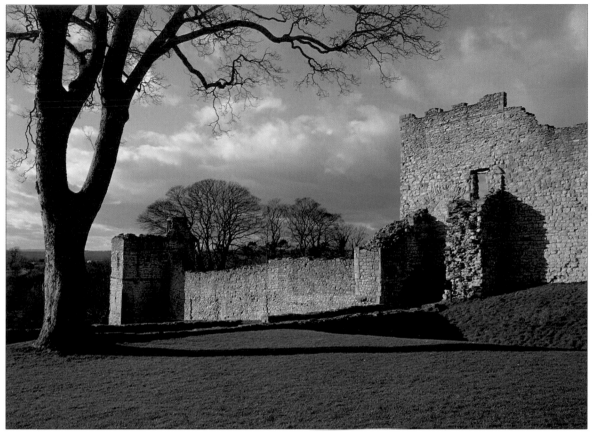

Pickering Castle
Wooden castles were vulnerable to fire, stone ones, in turn, vulnerable to 'firepower'.
In time castles ceased to have the same purpose to protect the rich and powerful,
as the need to safeguard whole towns and villages became more important.

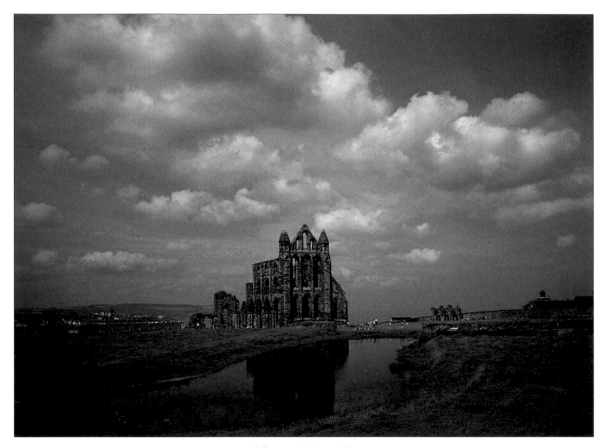

Monastic 'mania'
A resurgence in monasticism followed the Norman Conquest, especially in the moors.
The first order to arrive here were the Benedictines, who founded Whitby Abbey in 1074,
close to the site of the earlier Celtic monastery.

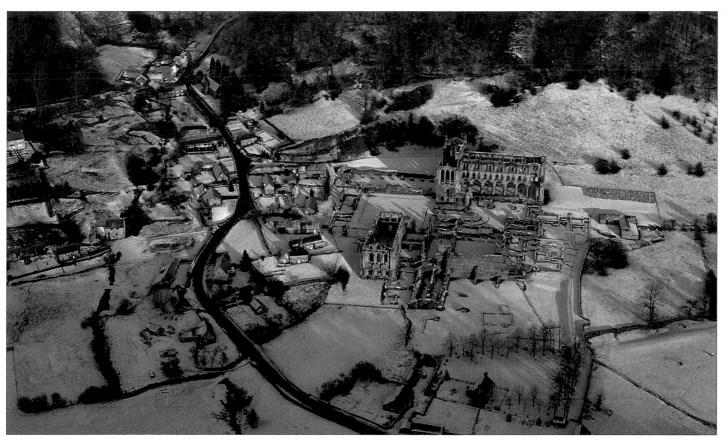

Engineering ingenuity
The Cistercians, who founded Rievaulx Abbey – pronounced 'reevo' – in 1131
moved the river to the other side of the valley to make the best use of space.

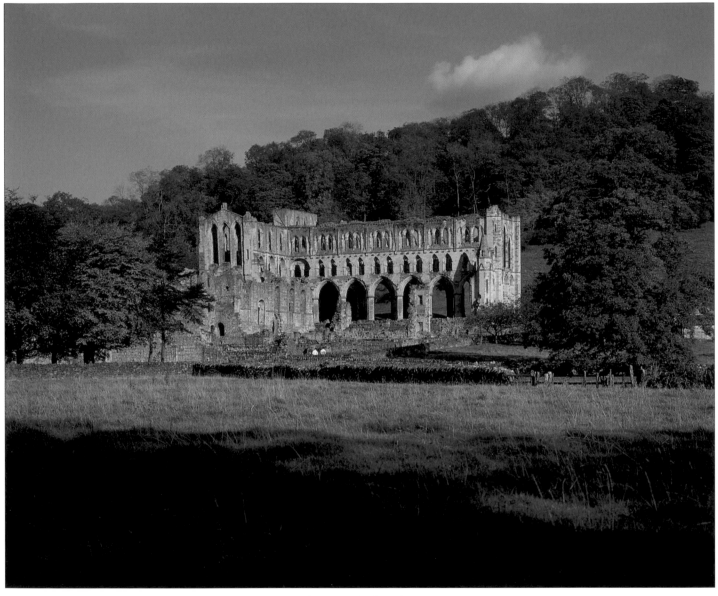

A romantic location
One of the great settings of any monastic house in Britain, Rievaulx entices the visitor to contemplate the nature of the world here nine centuries ago.

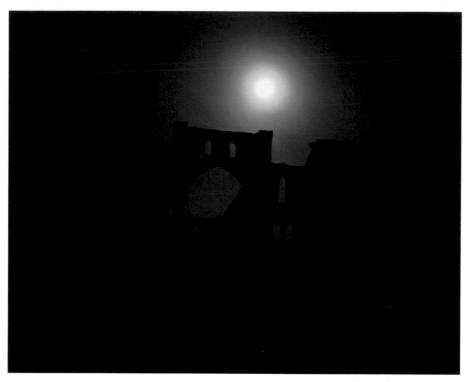

Firing your imagination
*On a foggy moonlit night, the restricted vision makes it all the easier to drift into
imagination about the people who lived at Rievaulx, and lives they led.*

Medieval magic
The distinctive shape of the ruined west end of Byland Abbey, founded in 1177, is unforgettable, especially when silhouetted by moonlight.

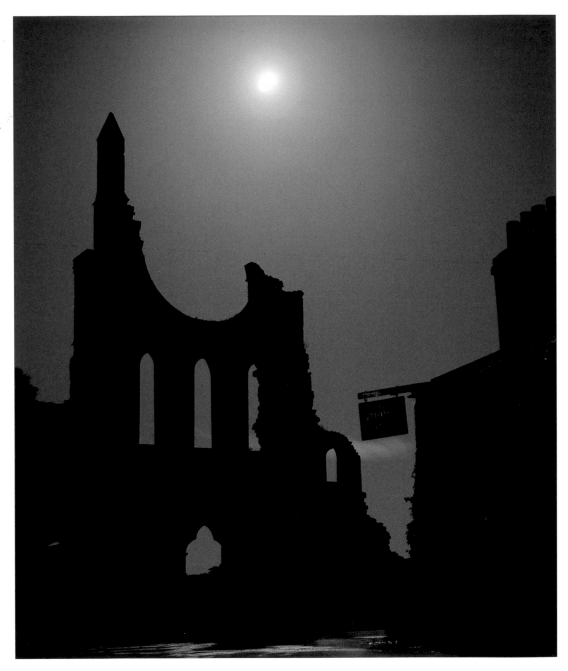

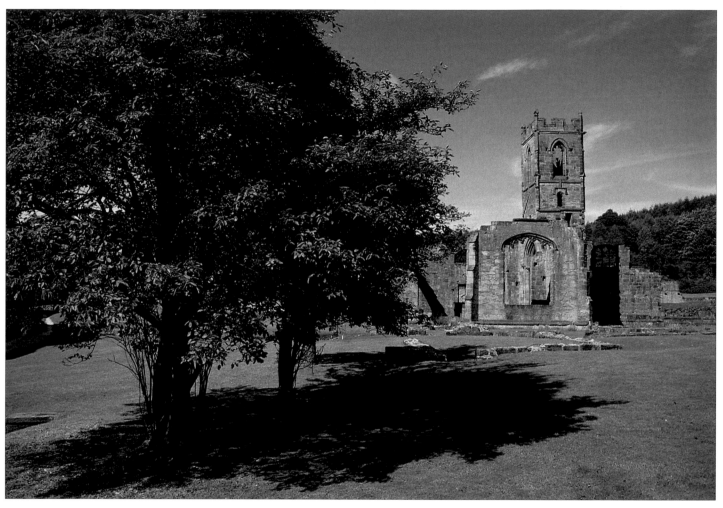

The meaning of solitude
The Carthusians took isolation to an extreme at Mount Grace Priory, founded in 1396,
with each monk living in the hermit-like seclusion of his own cell.

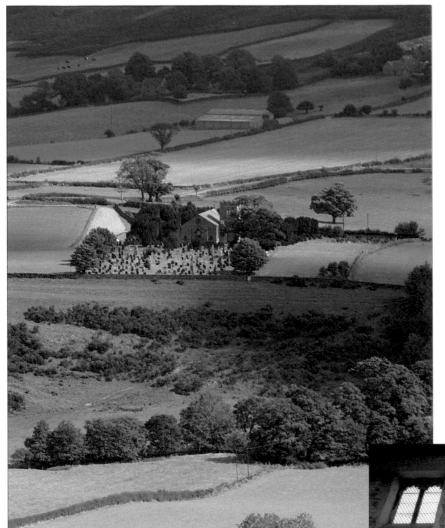

Community focus
The most tangible expression of the cultural heritage of this country is to be found in the parish and other churches such as Danby church.

Below: Fearful biblical scenes
Historically churches were once highly-decorated and colourful places. Pickering parish church is home to one of the most complete examples of medieval wall paintings in the country.

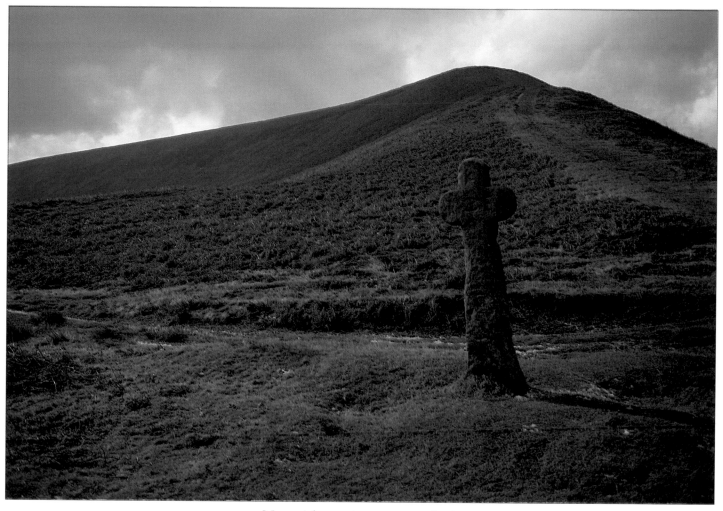

Memorial, warning or waymarker?
Wayside crosses are a historic feature of the moors, but their origins and purposes are often obscure.
However, Malo Cross at Whinny Nab is recorded as being a waymarker in the early seventeenth century.

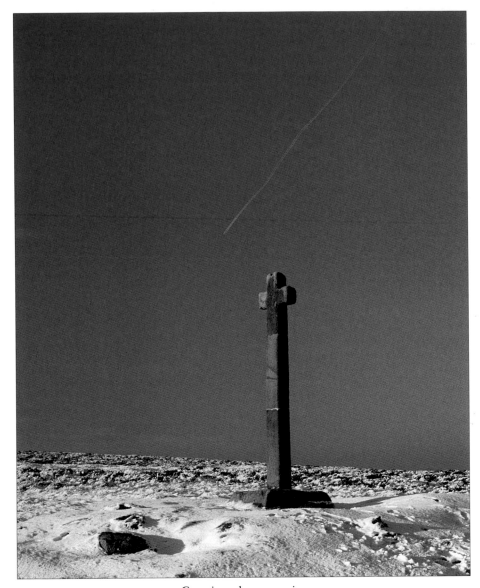

Crossing the centuries

Ralph Cross, in juxtaposition with a high-flying Boeing 747 provides an intriguing focus
to the contrast in technological and cultural eras which each represents.

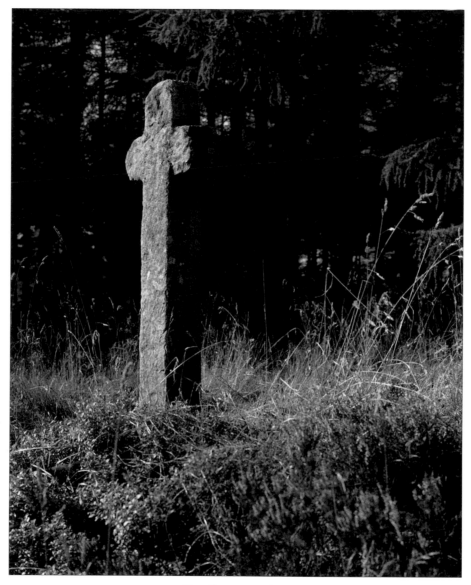

Family connection
Lying in the edge of the forestry plantations at Cropton Forest near Snape, Mauley Cross is named after the de Mauley family of Mulgrave Castle.

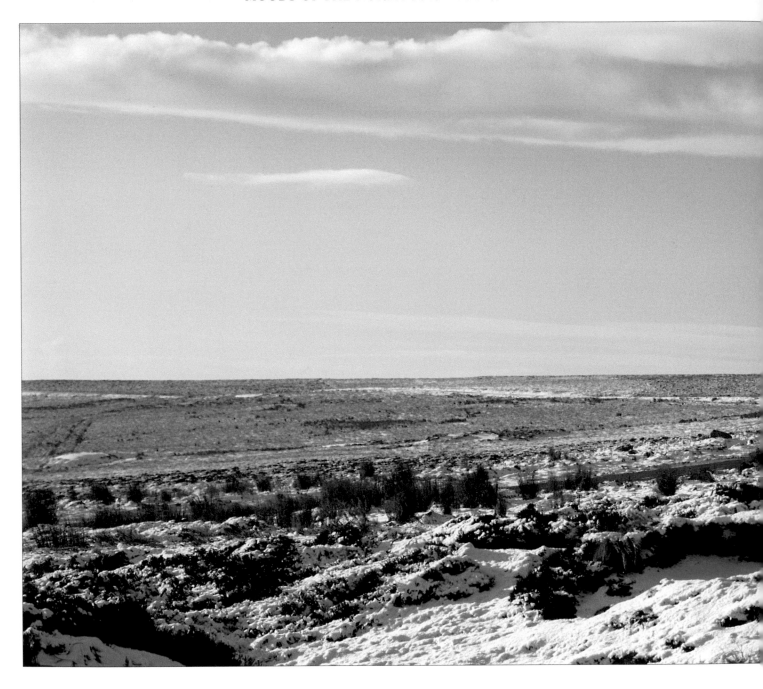

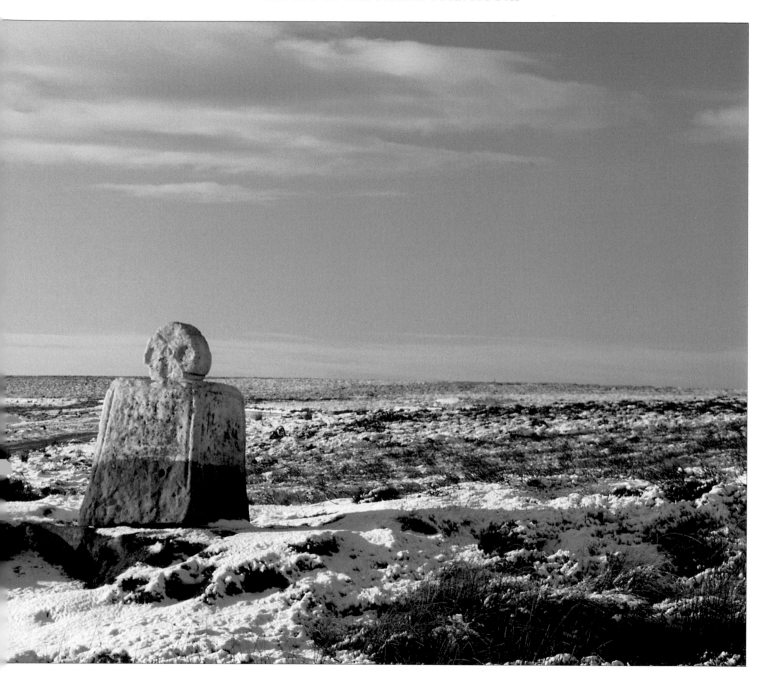

Accolade to an icon
The huge obelisk erected to the memory of Captain James Cook on Easby Moor in 1829 was a fitting, if long-overdue, testimony to Cleveland's most famous son.

Previous pages:
Turned to stone
The story goes that a farmer from Castleton lost his wife on the moor one night, but all that could be found was the Fat Betty Cross, standing between Rosedale and Danby Dale.

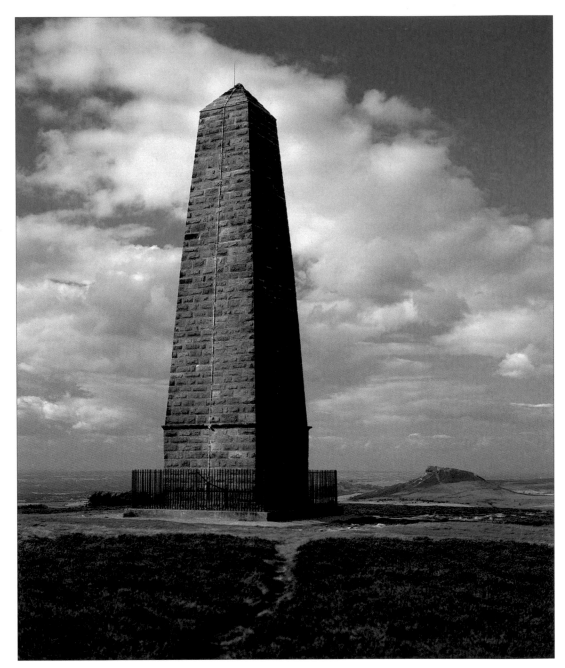

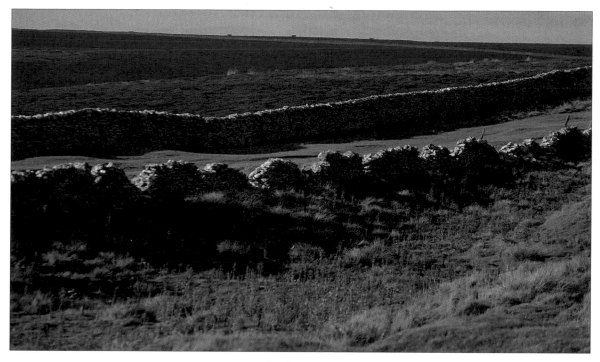

Ancient way
Stretching from Scarth Nick to Sutton Bank, the Hambleton Drove road is probably prehistoric, but is best known as the route along which drovers moved cattle to markets in the south.

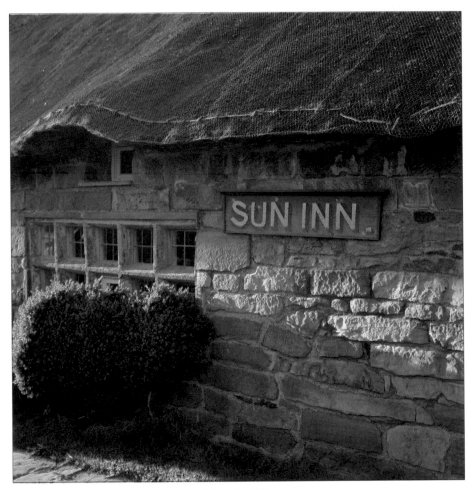

Oldest building

*Dating from the sixteenth century, Spout House or the Old Sun Inn,
sitting next to the New Sun Inn, Bilsdale is the oldest building in the
National Park and is open to visitors.*

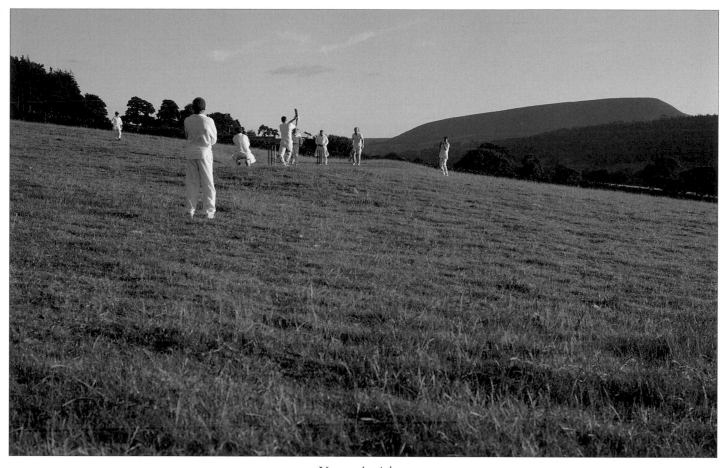

Unusual wicket
*A far cry from Lords, Headingley or the Sydney Cricket Ground, the Sun Inn is home to the Bilsdale cricket club,
playing on a pitch which owes its allegiance to the lie-of-the-land.*

Rural reminders
*Extensive collections of historic
rural equipment and artifacts
complemented by examples of
historic buildings from the
area bring the past alive at
the Ryedale Folk Museum
in Hutton-le-Hole.*

Living in limestone ...
Across the south of the Park, a belt of limestone gives rise to its extensive use in traditional houses.

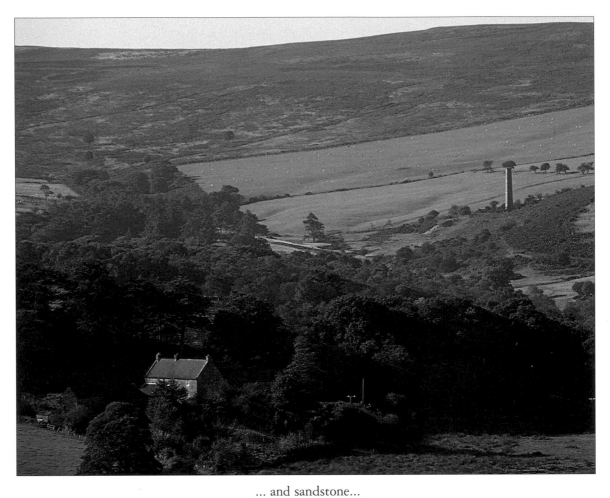

... and sandstone...
In the north, sandstone predominates and buildings, such as this remote house reflect the change in the geology.

... and bricks

Commondale is unique in the Park in that many buildings were constructed
in the past from brick, produced in a local brickworks.

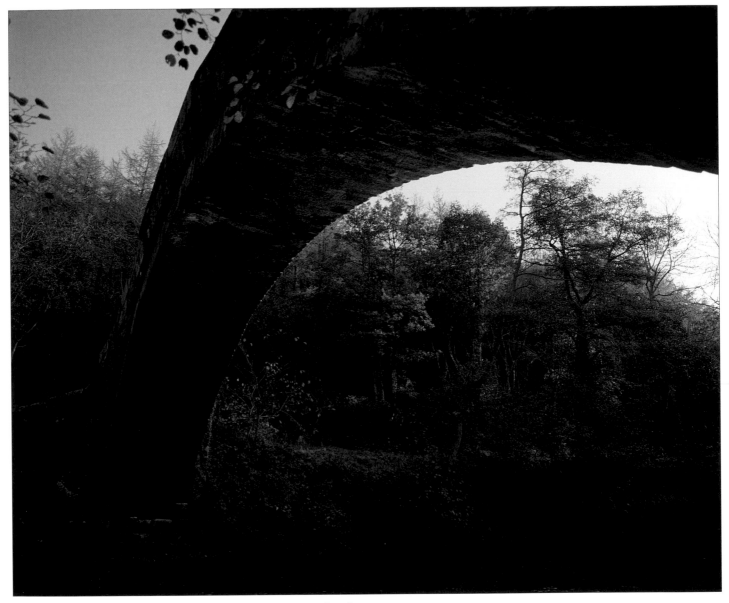

An elegant span
The River Esk was crossed by several single-span packhorse bridges, including the elegant
Beggar's Bridge at Glaisdale, linked to a legendary lovers' tale.

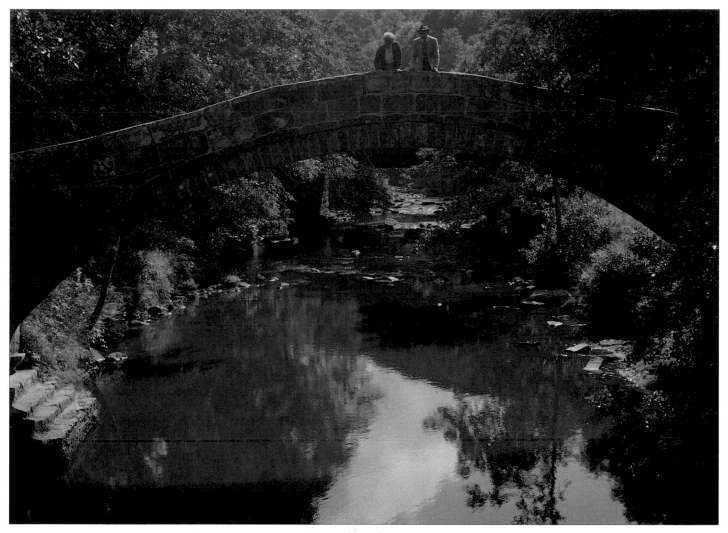

Cause for reflection

An opportune moment on Beggar's Bridge to contemplate the wealth of heritage which belong to the moors, and the way it has avoided the sweeping and often unforgiving hand of the modern world.

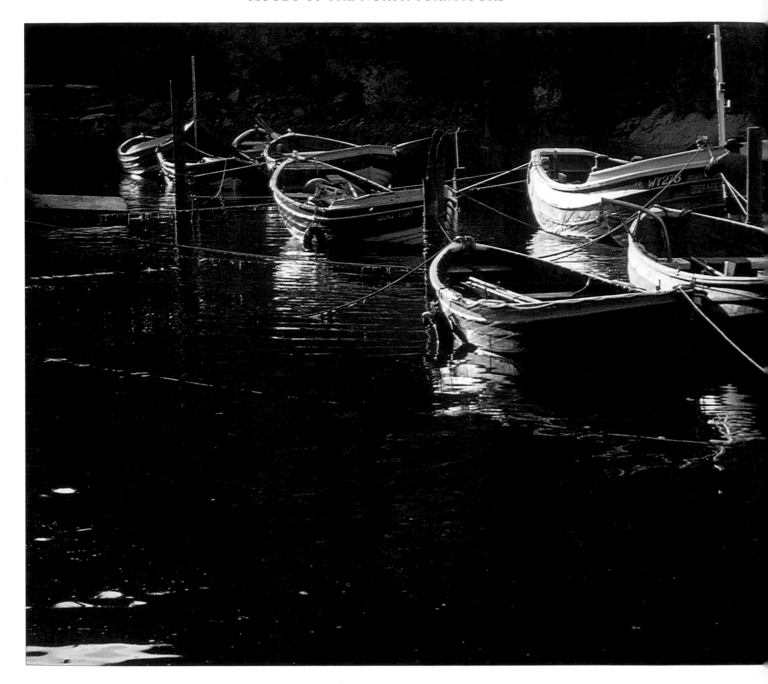

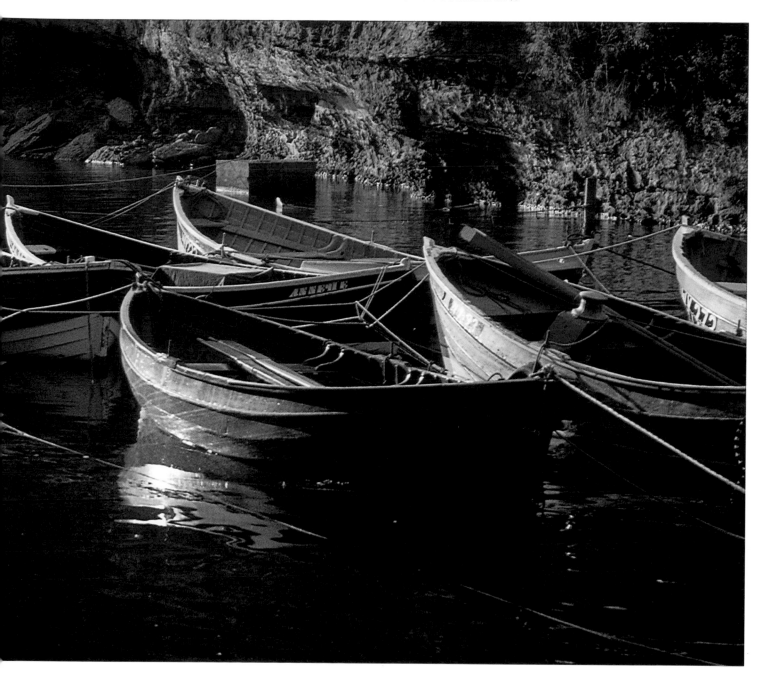

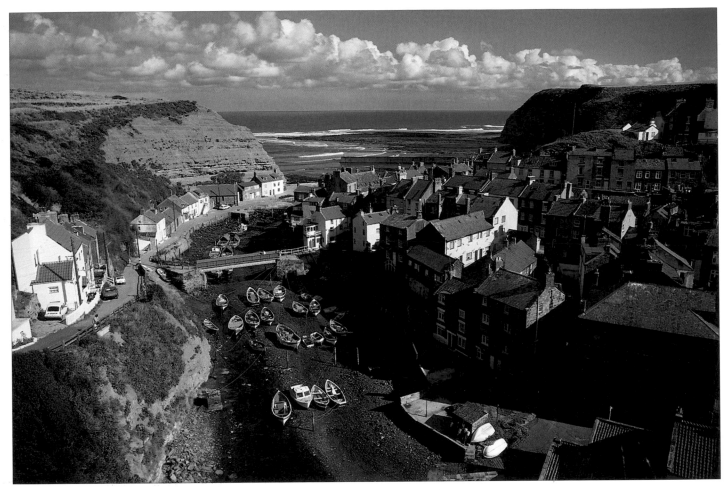

Tiny harbour – inspiring setting
First recorded in the early fourteenth century, tucked in the mouth of Roxby Beck and behind the promontory of Cowbar,
Staithes has a unique historic charm all its own.

Previous pages: Viking descendants
Traditional Yorkshire 'cobles' with their blunt sterns, are reputedly descended in design from the Viking longship,
and can be seen among other craft in local inshore fishing fleets.

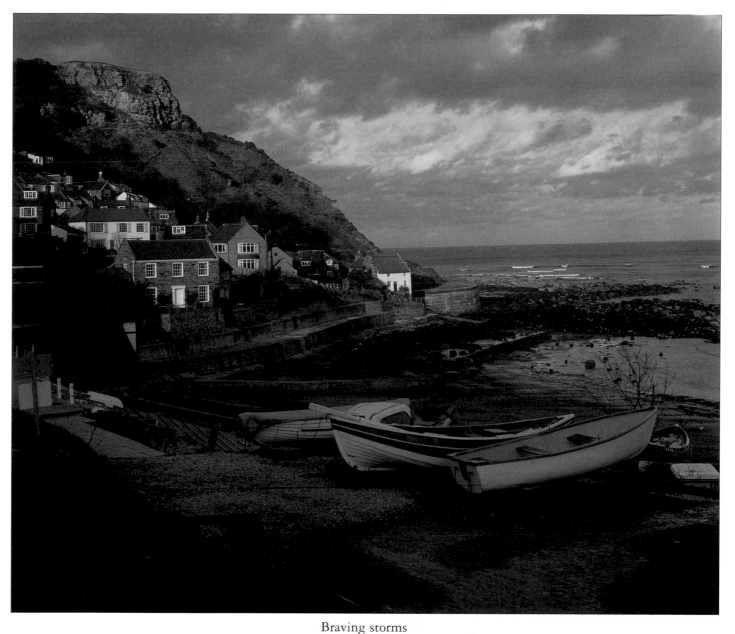

Braving storms
Runswick Bay, like the handful of other coastal settlements, seems to huddle against the potential threat of North Sea storms.

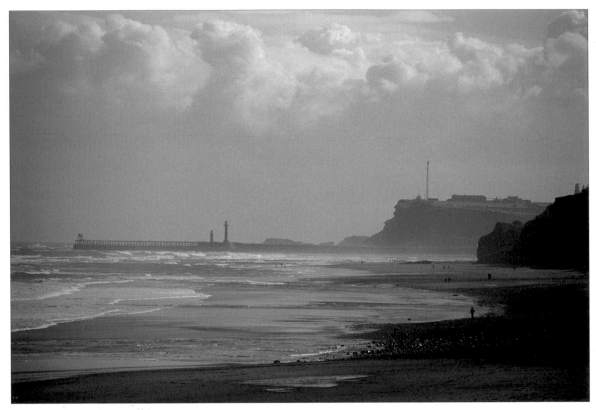

Landlocked by the moor
Whitby harbour mouth juts into the North Sea. With the high moors and their difficult winter weather behind, it used to be said that the only way to Whitby was by sea.

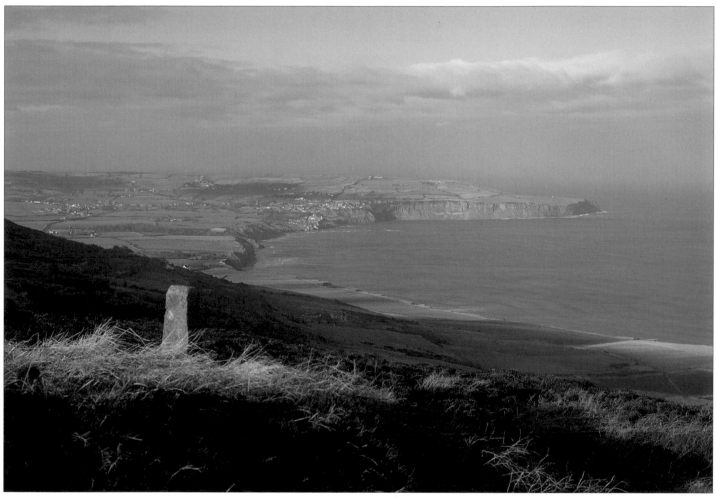

Rising behind the coast
The view over the sea from Stoupe Brow emphasises the physical barrier that the high moors would have presented in days of poor roads and horse-drawn travel and transport.

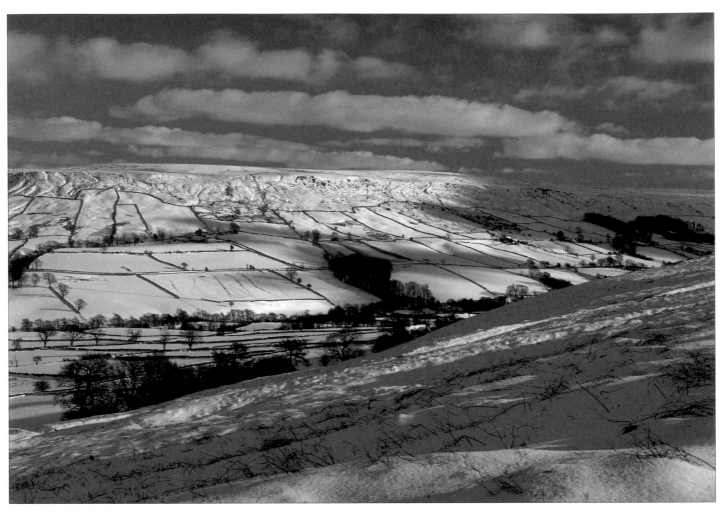

Harsh weather
Severe weather can extend well into the spring. Danby Dale after a March snowstorm.

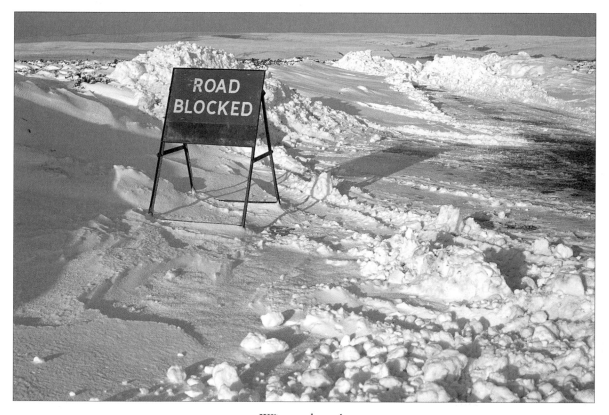

Winter obstacle
*Even today, with modern snow-clearing equipment, severe weather
on the moors can present a treacherous challenge to travellers.*

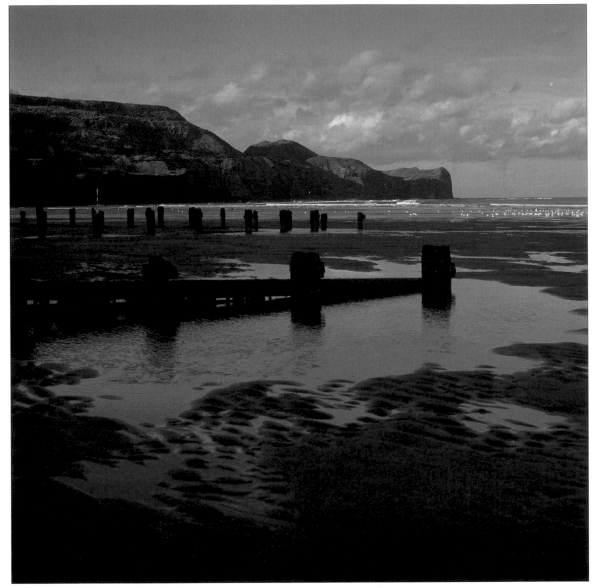

Quarried away

Vast quantities of alum shale were needed in the production of alum crystals, used as a fix in the dyeing trade in the eighteenth century. At Sandsend Ness, quarrying completely changed the shape of the headland.

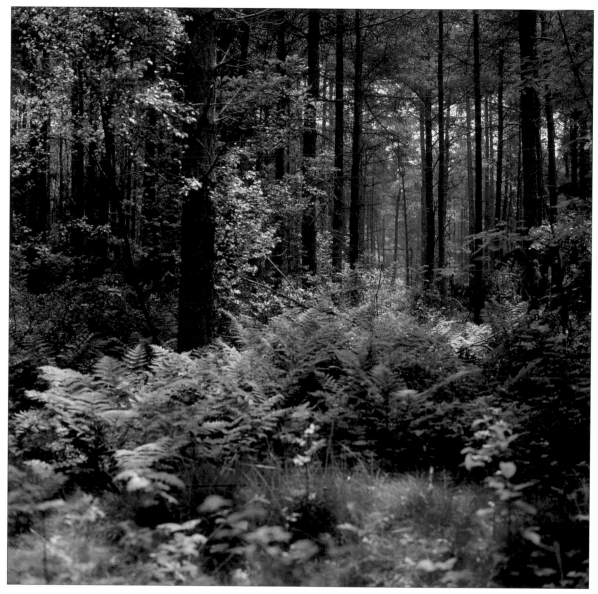

Meeting a strategic need

After the First World War, vast commercial forests were planted in the south-east and north-west of the moors to provide a strategic timber resource, but today have also become highly valued for recreation.

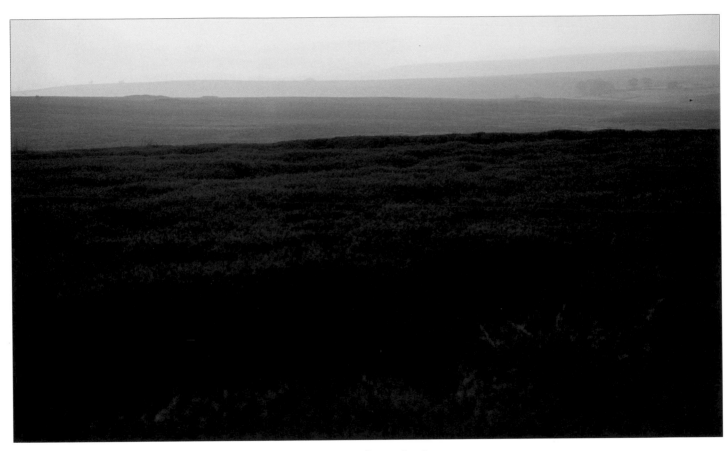

Essence of moorland
Treeless ridges disappearing into emptiness provide an extreme contrast to the hustle and bustle of modern city life, making it hard to believe that central London, Leeds or Manchester actually exist.

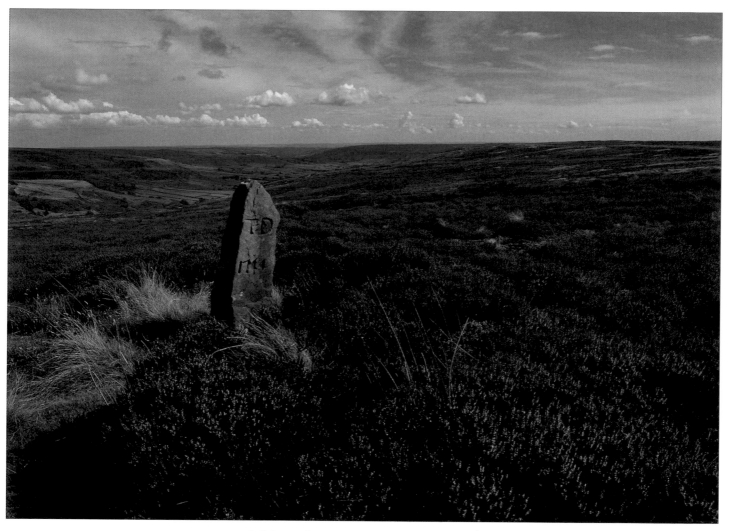

Public and private – a vital combination
Almost all of the moorland is privately owned and managed for grouse shooting by periodic burning,
without which it would be economically impossible to maintain the landscape we enjoy.

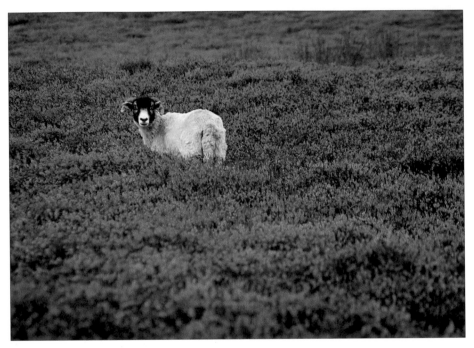

Nature's conservationists – in moderation
*The 'great nibblers' help control taller-growing vegetation and keep the heather
naturally pruned, but too many animals in an area can result in harmful overgrazing.*

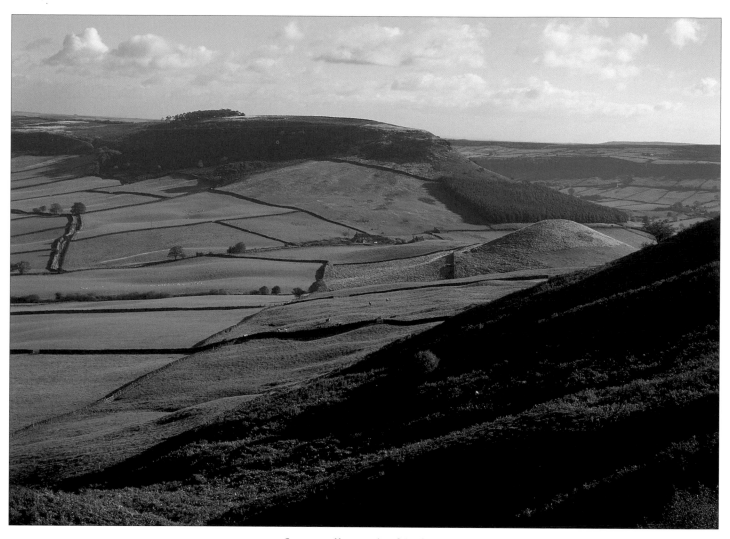

Stone walls – upland hedges
A harsher climate and ready supply of building materials resulted in stone walls being used to mark field boundaries and to enclose animals, as seen here in Little Fryup Dale.

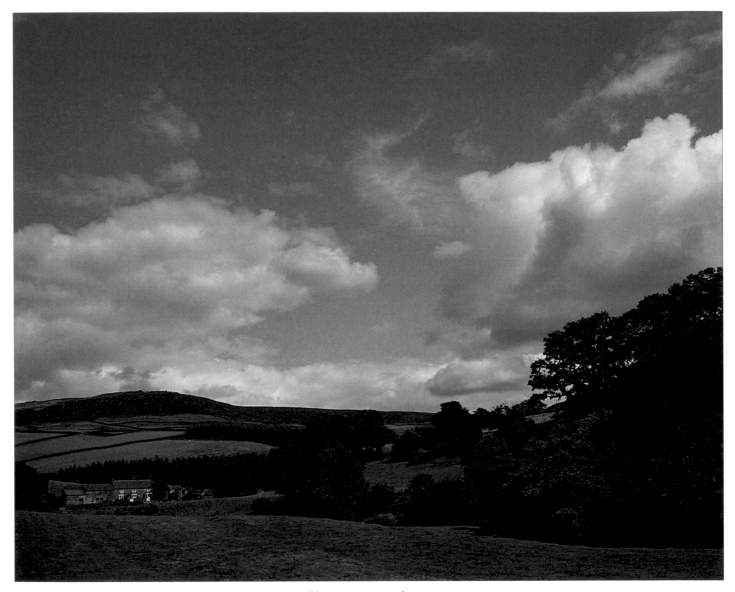

Clue to a pastoral past
Isolated farmsteads spread throughout the landscape, such as this one in Bilsdale,
are a sure sign of an historic tradition of dependence on pastoral farming.

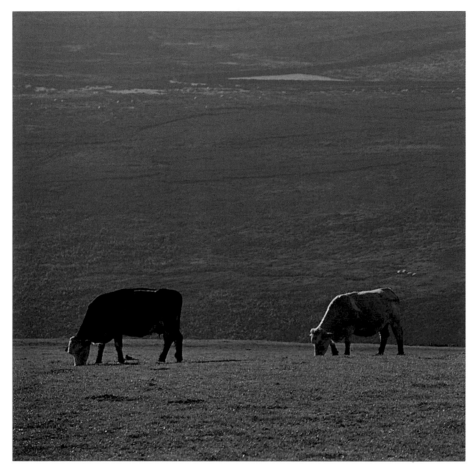

Declining asset

In past centuries cattle would be run up to the moor edge, helping by coincidence to
trample and control invasive bracken. But changes in farming practices and economic
pressures threaten the upland farming on which the character of the Park depends.

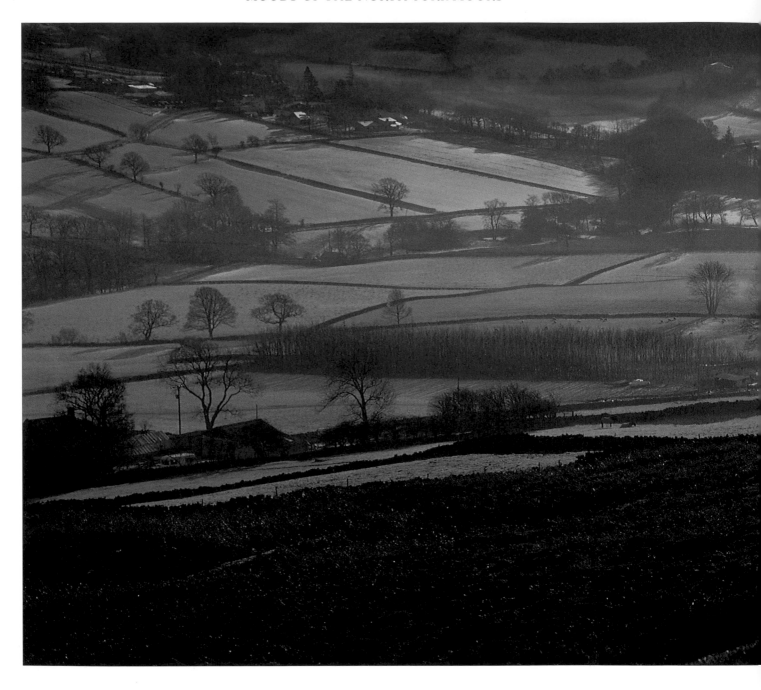

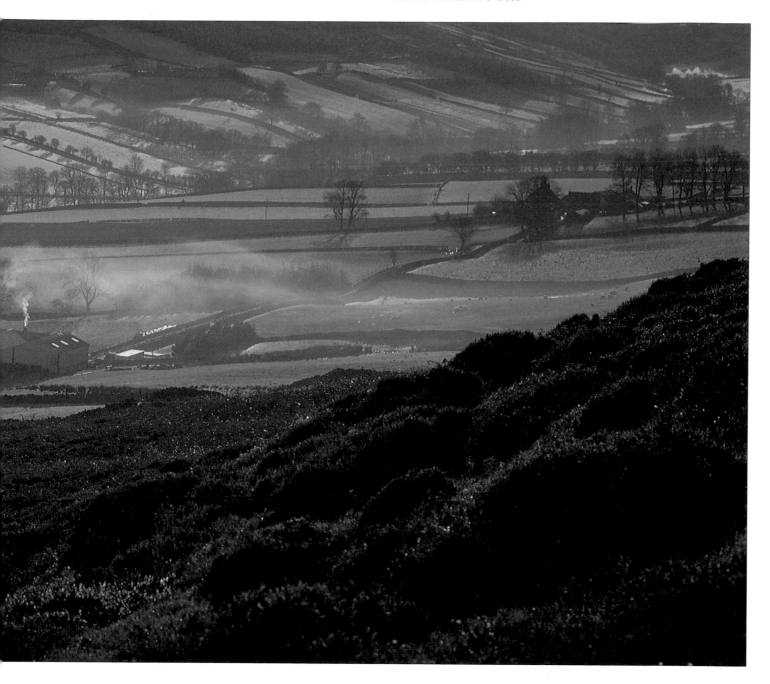

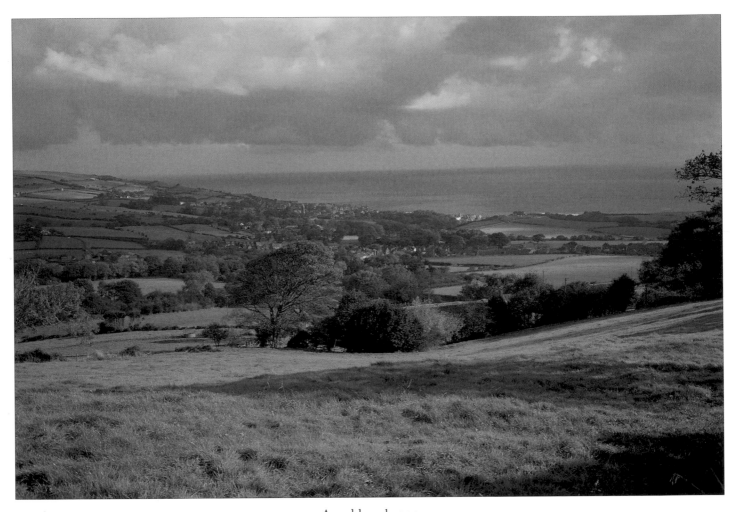

A sudden change
The dark moor gives way to farmland along the coastal strip at Fylingthorpe where boulder clay was deposited at the end of the Ice Age.

Previous pages: Winter afternoon
A peaceful scene, looking from Castleton Rigg across Danby Dale towards Botton Hall on a mid-winter's day.

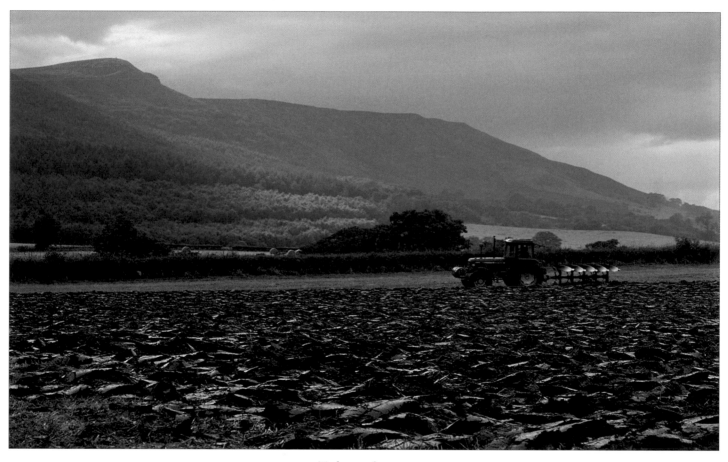

Tasks made easy
Modern equipment makes light work of arduous tasks such as ploughing on the Cleveland Plain below the high moors near Ingleby.

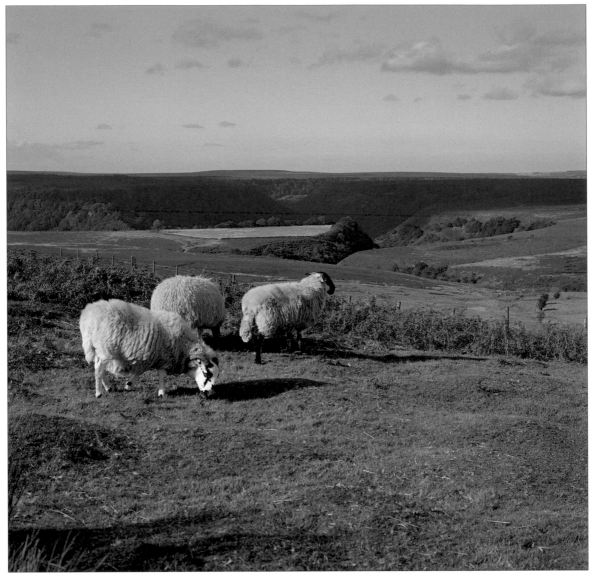

'Moorjocks'

'Moorjocks,' the local name for the hardy moorland sheep, grazing on
Lockton Low Moor – a timeless scene.

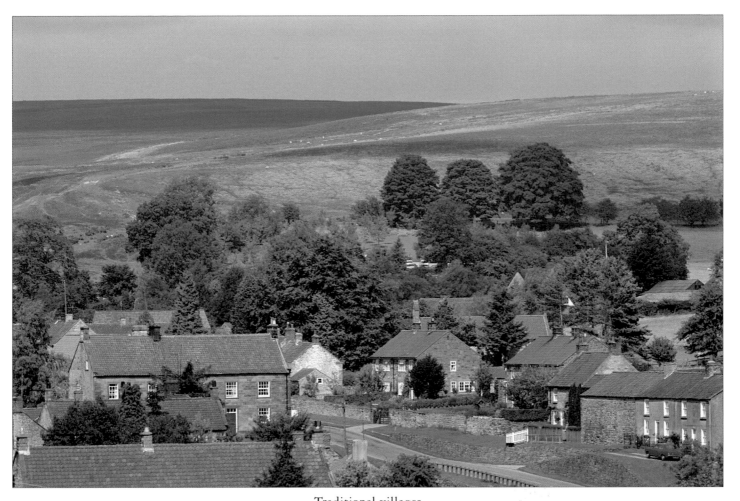

Traditional villages
Hutton-le-Hole named after the howes (burial mounds above it on the moor), is a renowned village
with visitors and the home of the Ryedale Folk Museum.

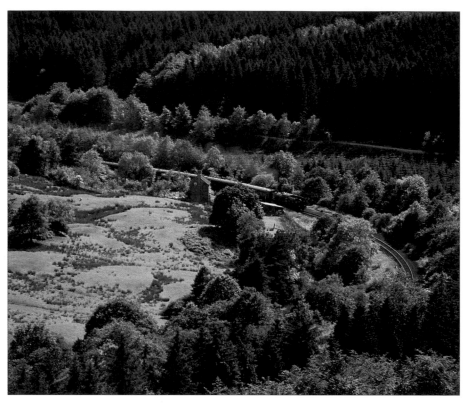

Forefront of industrial innovation
With the coming of the railways, Whitby saw a chance to improve its links with the rest of the country and in 1836, what the Ice Age had bequeathed provided an ideal route for a new railway to Pickering down Newtondale.

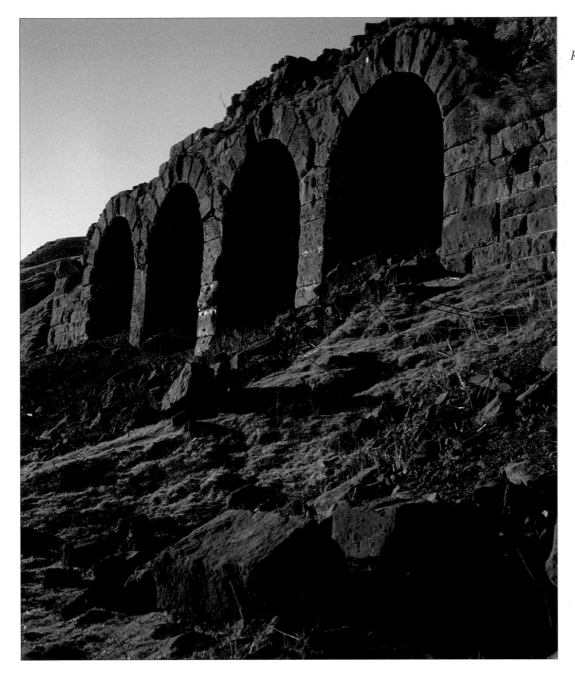

Fascinating legacy
Remains of the kilns where ore from the long-gone Rosedale iron mines was burnt to reduce its weight before transport by moorland railway to the industrial areas of the north-east.

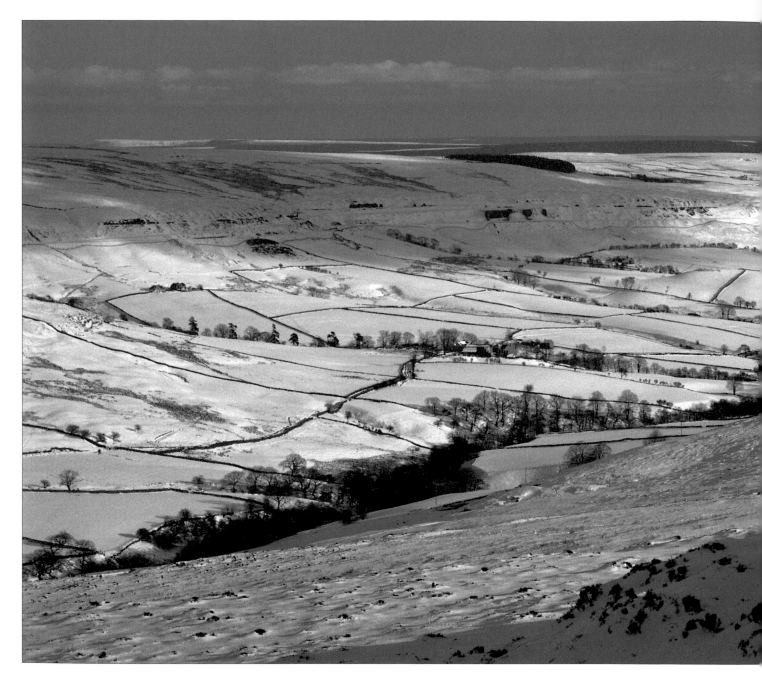

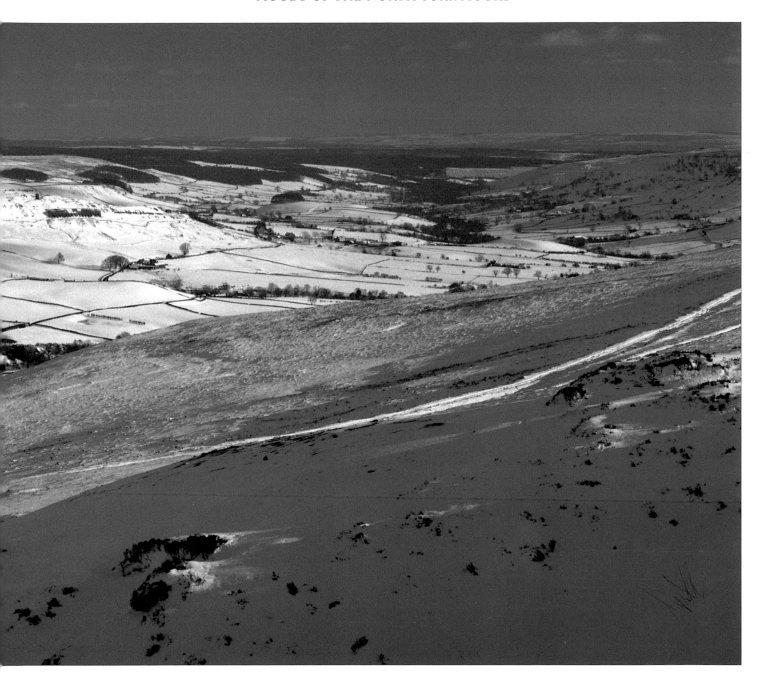

A precarious proposition
*Near Ingleby Greenhow,
wagons of iron-ore from
Rosedale were uncoupled
and lowered by rope down a
dizzily steep incline,
with inevitable accidents
from time to time.*

Previous pages:
An unusual railway
*The track-bed of the
disused mineral railway
running round the northern
half of Rosedale makes for a
superb level walk of several
miles with stunning views.*

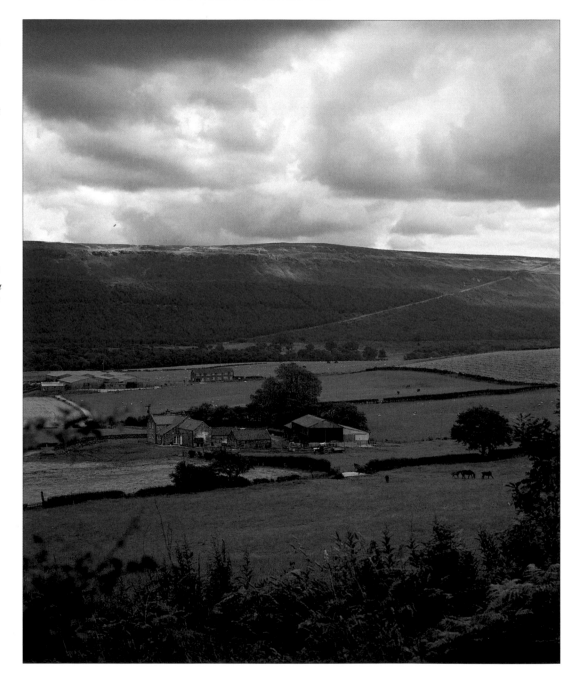

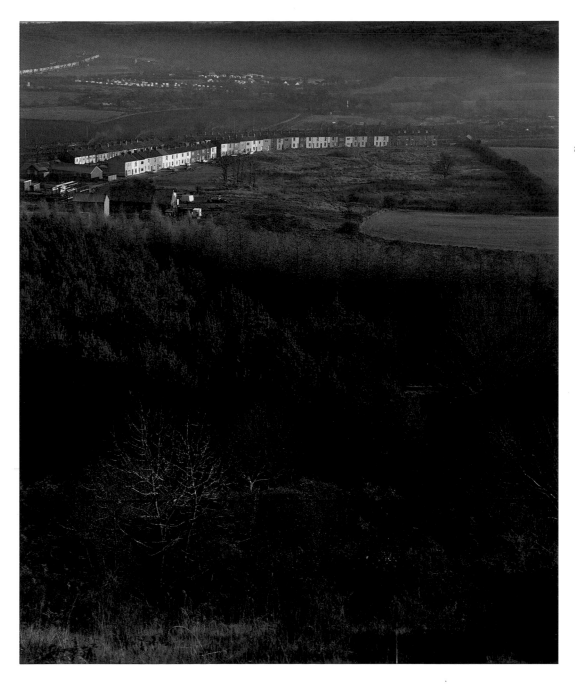

Mining communities
Iron mining survived in East Cleveland until the mid-twentieth century. The distinctive terraces of miners' cottages at Charltons are a reminder of this major historic industry of the area.

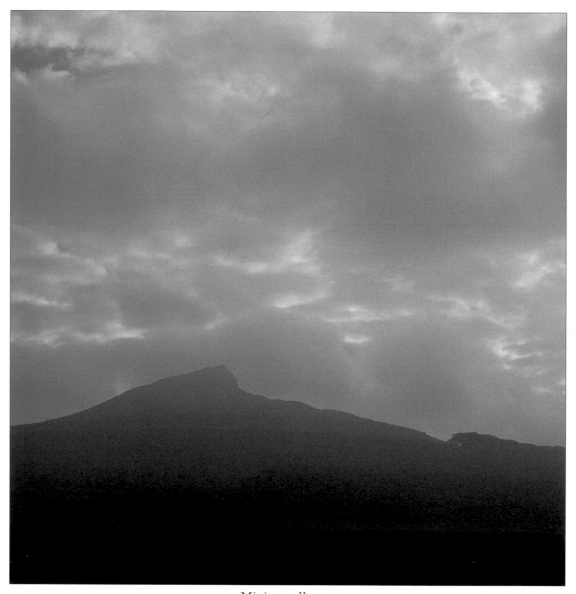

Mining collapse

*Teesside's favourite landmark, Roseberry Topping, lost its western face when undermining
for iron ore caused it to collapse in the nineteenth century.*

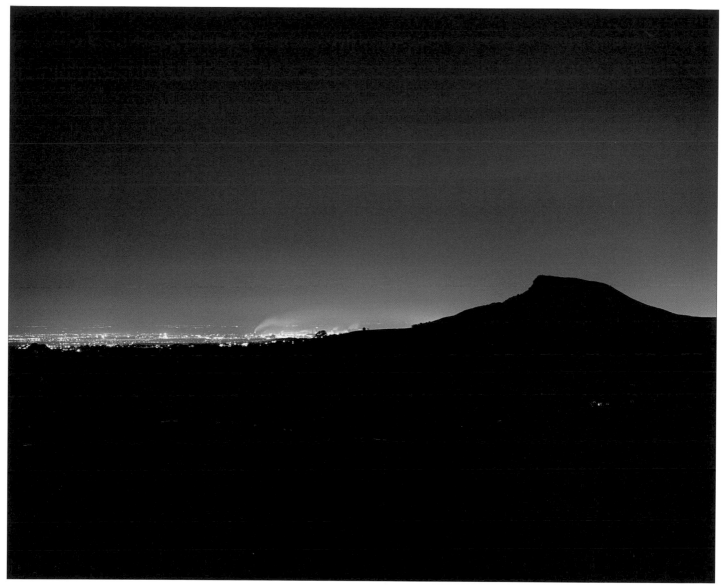

Ten miles from Teesside

A night-time view from Easby Moor reveals the contrast between the deep rural moorland landscape and the the huge conurbations and industrial zones of Teesside, only a stone's-throw beyond.

Lime for the land
*Time and nature have
smoothed the evidence of
quarrying and mining,
but clues to these industries
can still be detected across the
face of the land, such as at
Kepwick limestone quarry.*

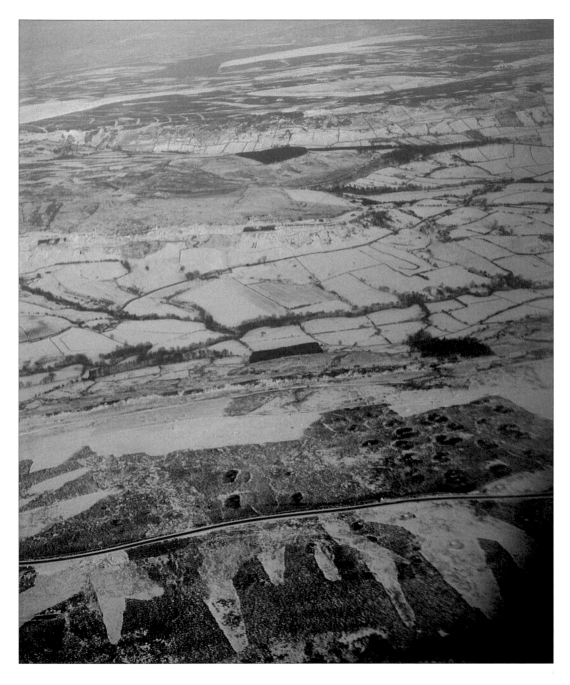

Coal for the fire
Coal was mined here too. From the air a dusting of snow on a very gloomy winter's day, outlines circular shapes on Farndale Moor, near Blakey Rigg. They look like burial mounds, but are small 'bell' pits from which coal was dug by hand.

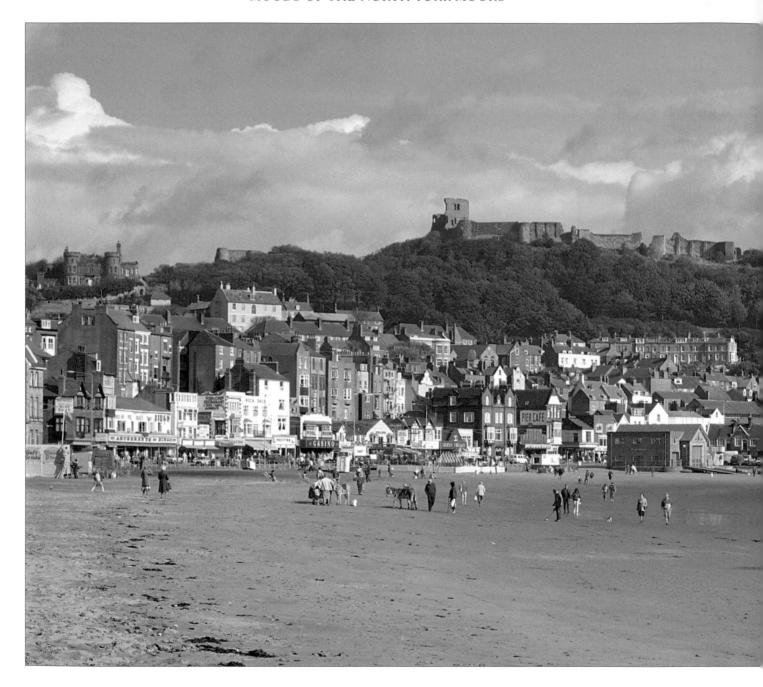

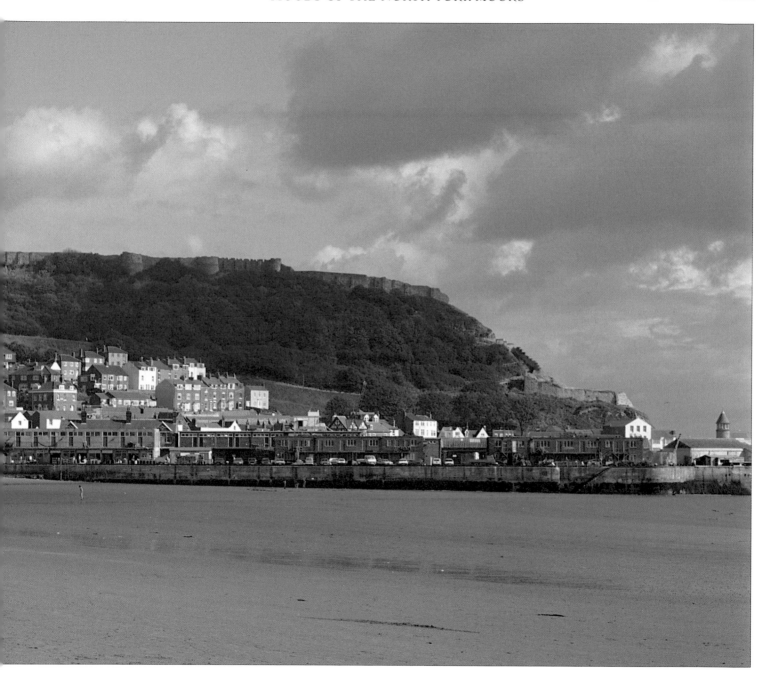

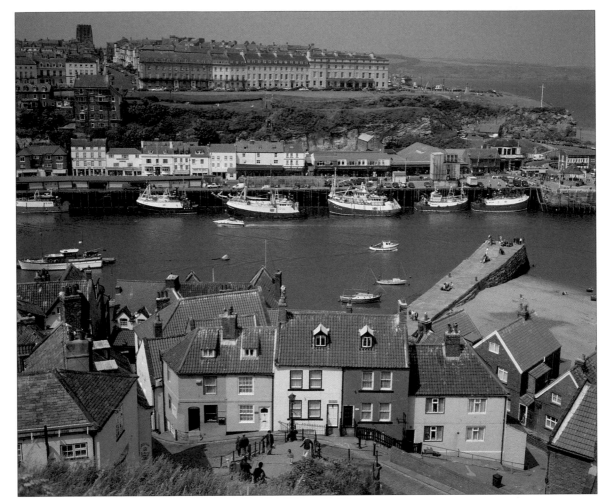

An unspoilt town
There is nowhere else quite like Whitby, perhaps the only large town in the country whose streets have not suffered the ravages of modern-style shop developments.

Previous pages: Tourism is born
The age of the train brought tourism to larger coastal towns, the heyday being perhaps before the First World War. Like a full-stop to the National Park, Scarborough remains a very popular place for a holiday and a fine base for journeys into the moors.

Failed dream

In the 1890s, an ambitious planned holiday town at Ravenscar promised a plot of your own, but almost completely failed. The odd person did, however, buy into the idea of Utopia here on the windswept cliff-top and built their 'dream home'.

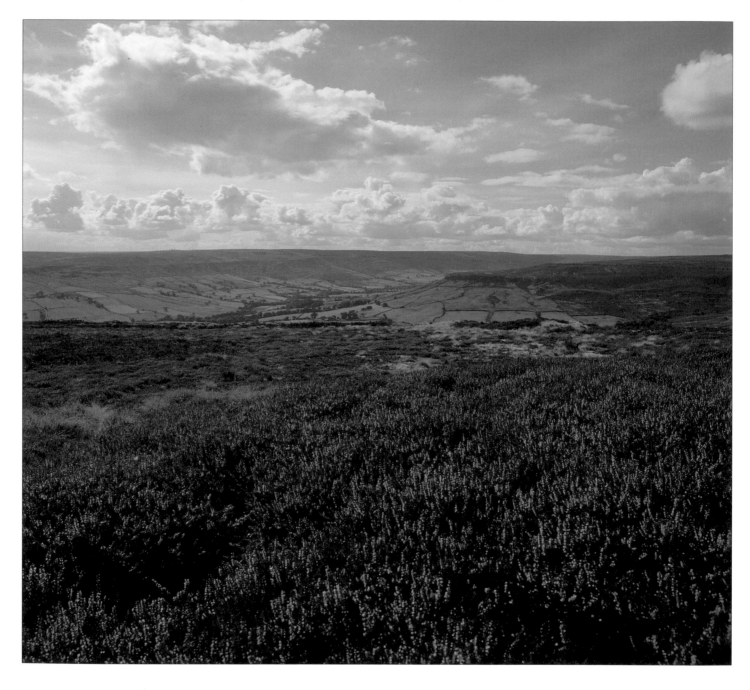

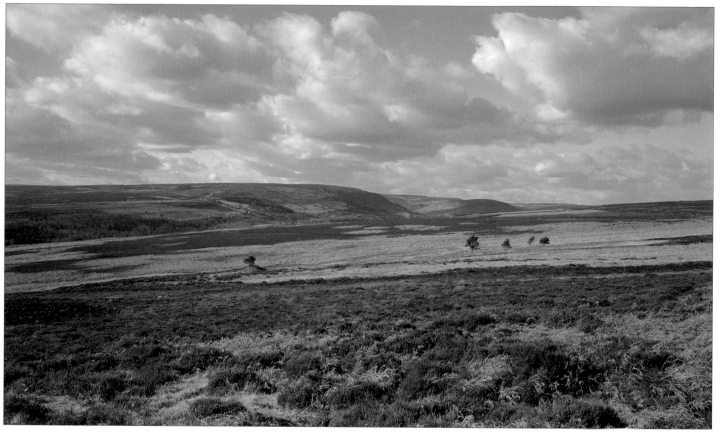

Wild ... yes?... Natural...not really

The moors appear totally wild and untouched by people, but like almost all of our countryside they are an expression of human activity over thousands of years, responding to the needs and fashions of the times.

Opposite: Protected for the nation

In 1952, the North York Moors, epitomized in this view into Farndale, was designated a National Park, a unique blend of private ownership and a special focus to ensure that our finest countryside would be protected both for us and for future generations.

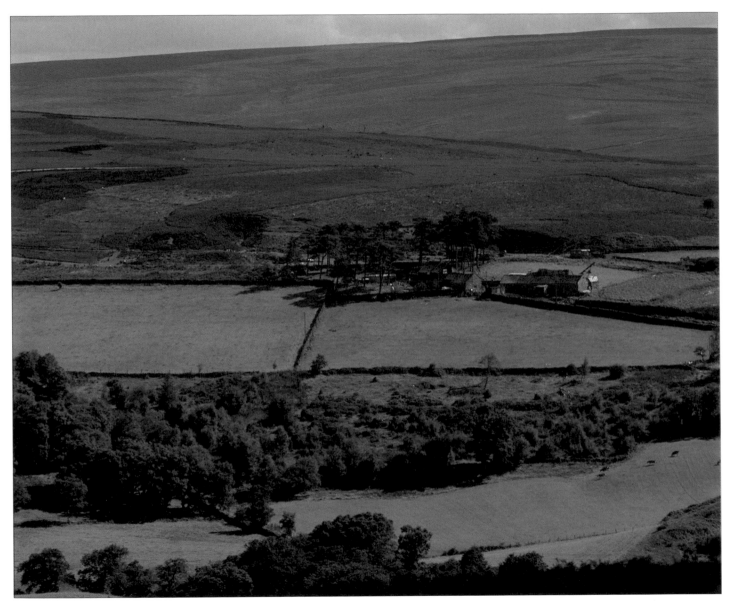

A double-decker landscape

The 'double-decker' landscape of dark moor above and deep emerald green valleys below is maintained almost wholly by the economic activity of grouse shooting and farming, with some help from environmental schemes.

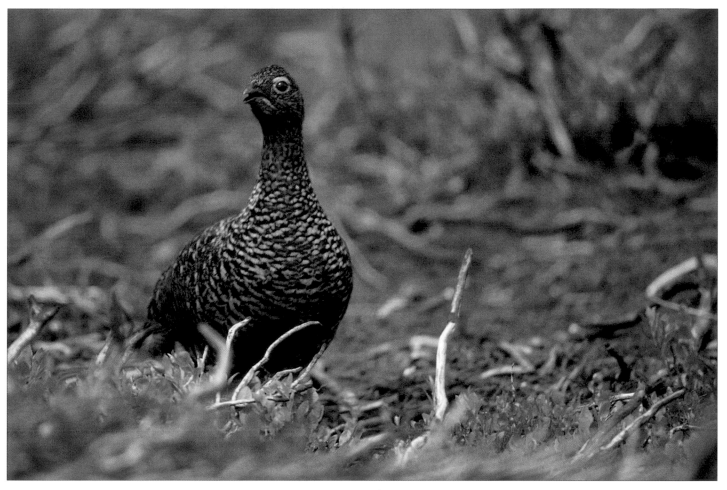

A unique bird

The red grouse lives only on the moorlands of Britain. Contradictory as it might seem, without the commercial interest from grouse shooting, maintaining the heather moor and its wildlife would be an uphill task.

Fatal trap

Although adult grouse eat heather, the chicks are taken to boggy areas where they are fed on insects. Maintaining these wet places is therefore vital to grouse and benefits bog-loving plants, like the tiny insect-eating sundew.

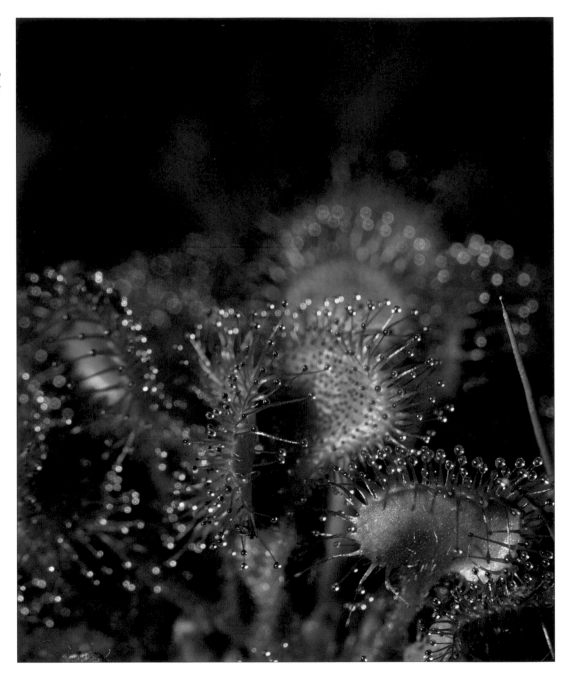

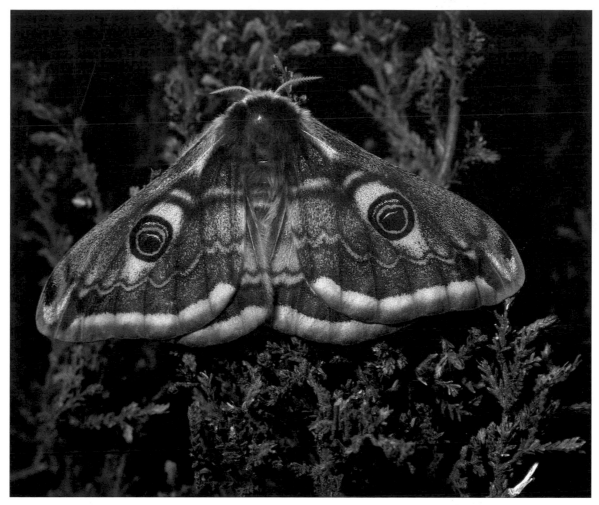

A world champion

A female emperor moth waits among the heather. Male emperor moths, which can be seen flying during the day in late April, are thought to have one of the keenest senses of smell on earth and can detect a female from perhaps 3 miles (5 kms) distance.

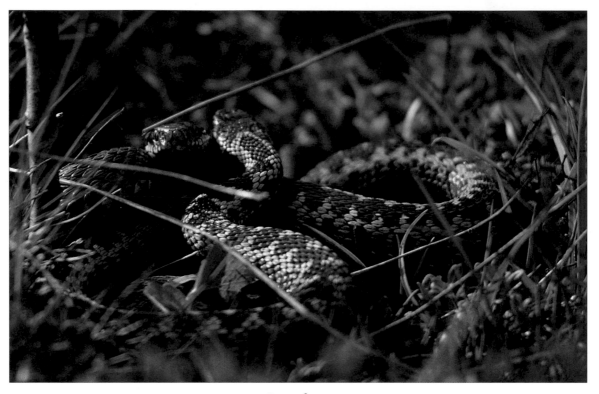

Inner fears
*What is it about snakes? We are fascinated and yet often terrified by them. Adders are quite common,
but slip away quietly when humans approach.*

Purple gives way to gold
A late summer season for the heather and an early autumn for bilberry and bracken creates an unusual
tapestry of intermingled colour on the moorside.

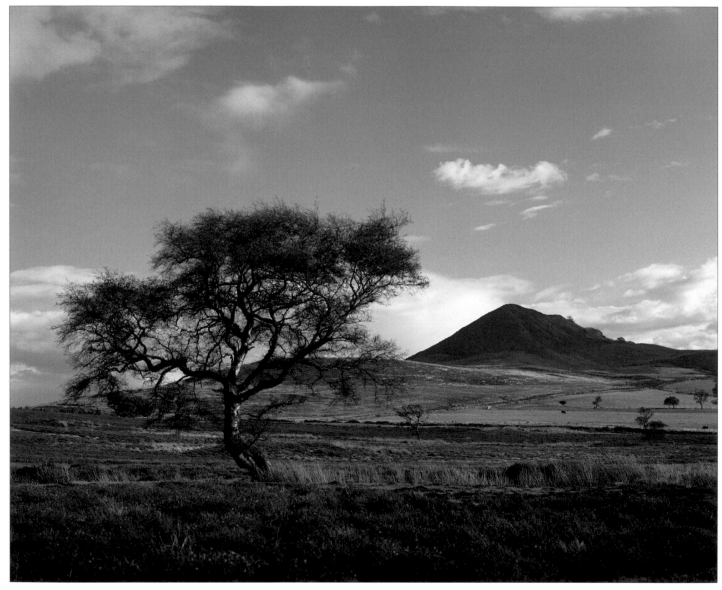

Holding the line for heather

A birch tree on the moor behind Hawnby. If moorland management for grouse and sheep simply stopped, within twenty years the landscape would be unrecognisable with rowan, pine and birch turning the open vista into woodland scrub.

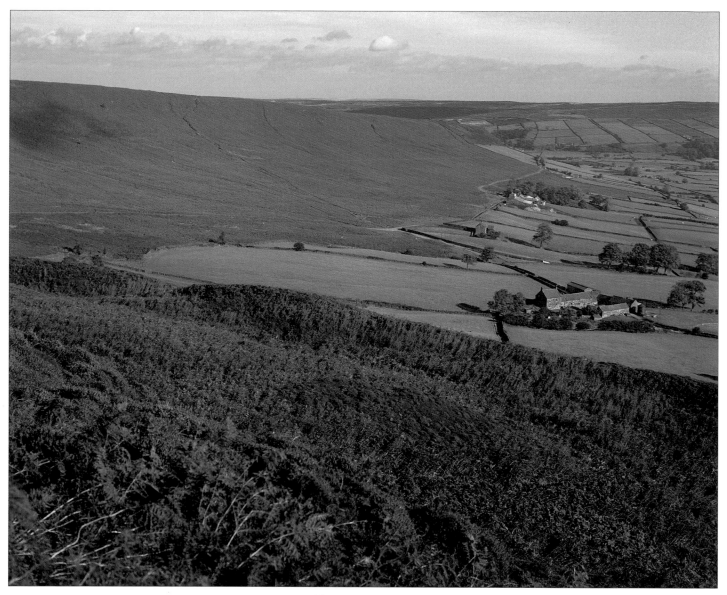

Wolf in sheep's clothing

Where heather is beautiful for a month, bracken is attractive the year round. But it is also very invasive and needs concerted control, demonstrating that beauty on its own is not a good criterion for conservation.

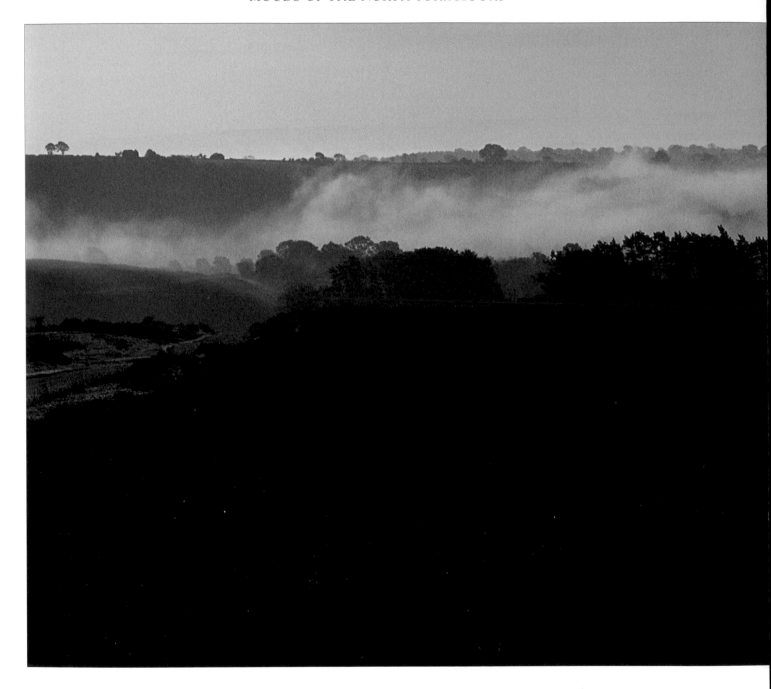

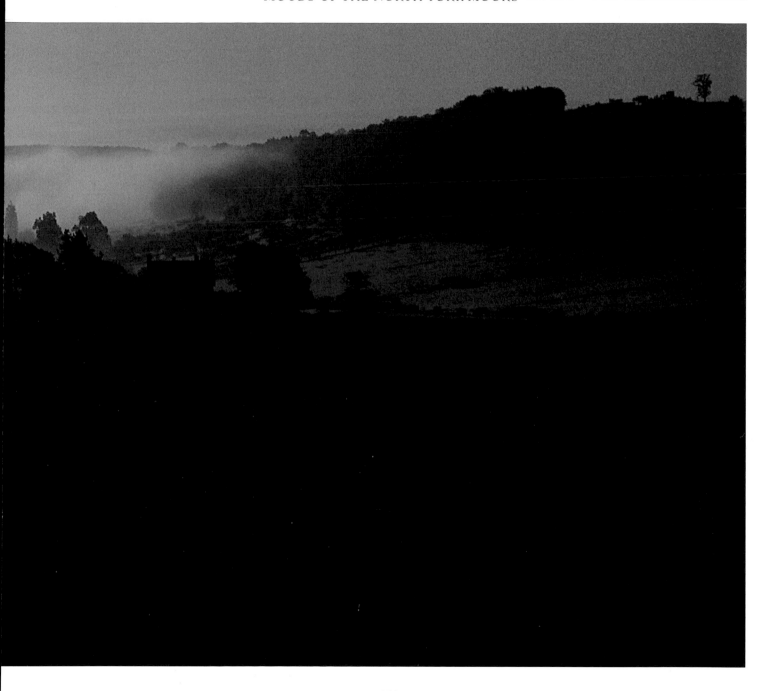

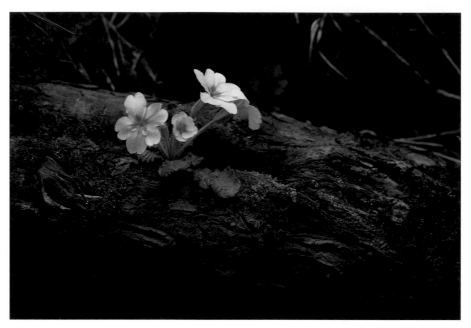

Spring woodland wonders
The roadside banks and ash woods are home to the earliest wildflowers,
with primroses cheering the countryside and heralding the turning of winter into spring.

Previous pages: Soft south
Mist cloaks the folds in the limestone hills of the south of the moors. Here in the tight
wooded valleys, meadows and roadside verges, a wide range of wildflowers is encountered.

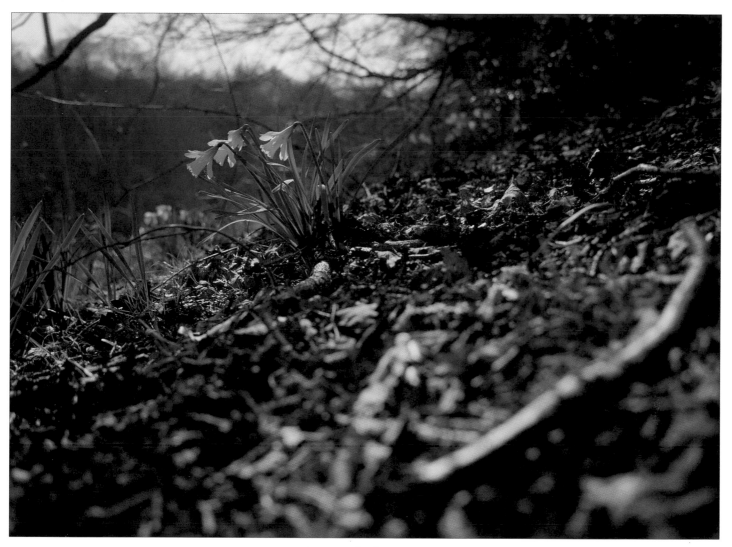

An annual pilgrimage
Each year the banks of the River Dove in Farndale come alive, not only with thousands of delicate wild daffodils,
but with people coming from far and wide to admire them.

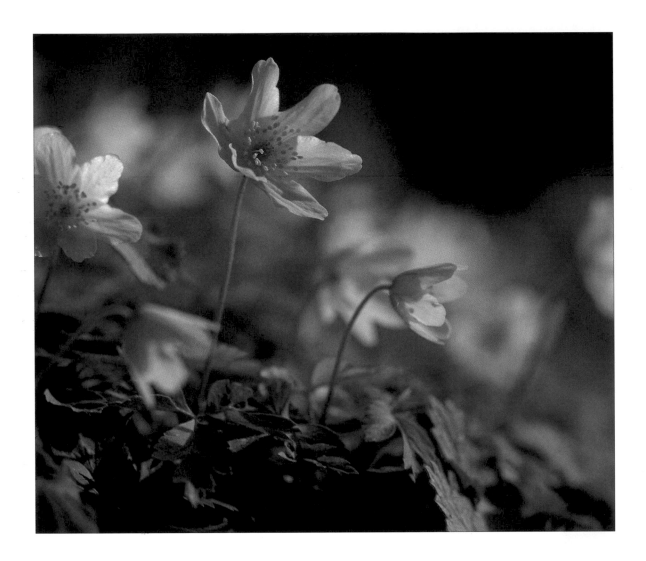

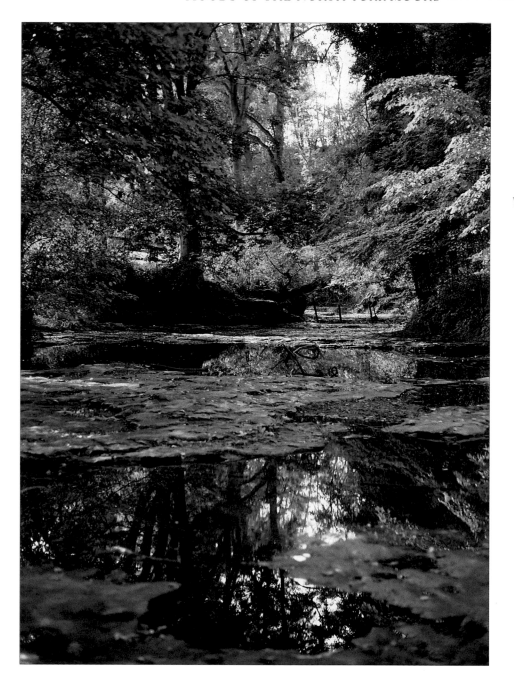

A river runs dry
In summer, the Hodge Beck dries up where the stream disappears underground into swallow-holes amongst the limestone rocks in Kirkdale.

Opposite:
A cheerful face to spring
Wood anemone or 'windflower' carpets the floors of many ancient deciduous woodlands.

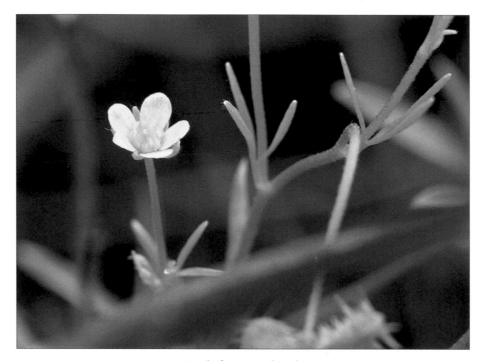

Back from the brink

Almost extinct, but not quite. A single corn buttercup plant was discovered and nurtured to provide seed, which was then multiplied at the Ryedale Folk Museum and planted out in its hundreds in a special arable field at Silpho.

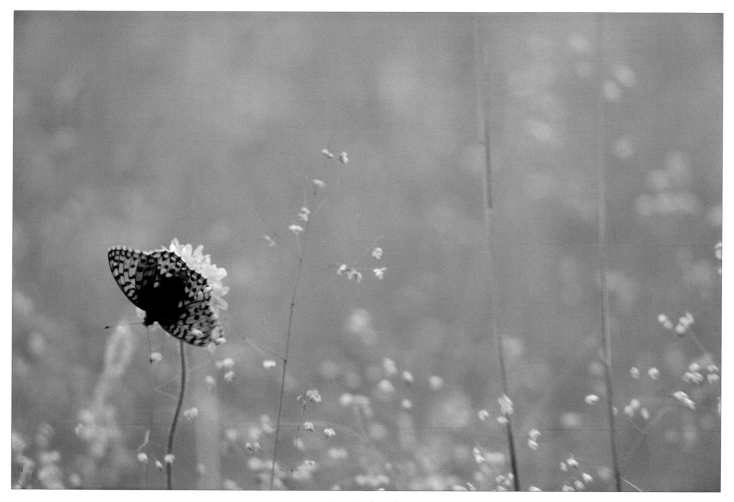

On the brink

Butterflies, such as the dark green fritillary, have suffered terribly in recent years, but sometimes can still be seen on a summer's day in one or two places in the Thornton Dale and Dalby area.

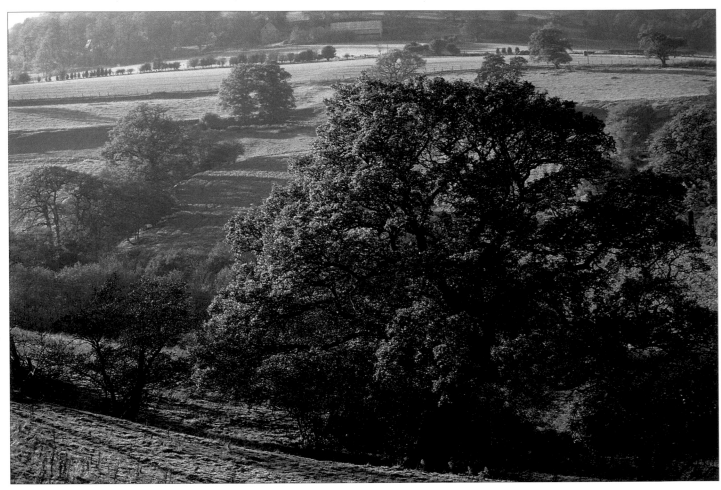

Summer slips away
An oak changes colour in a peaceful autumn scene close to Arden Great Moor.

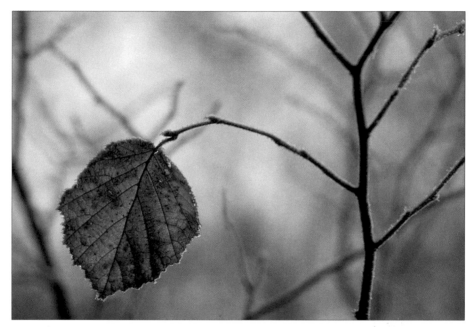

A last leaf
Management of ash woodland with hazel coppicing has largely died out,
but the tradition of cutting the hazels down to ground level every few years
encouraged a wide range of wildflowers, which would otherwise have been smothered.

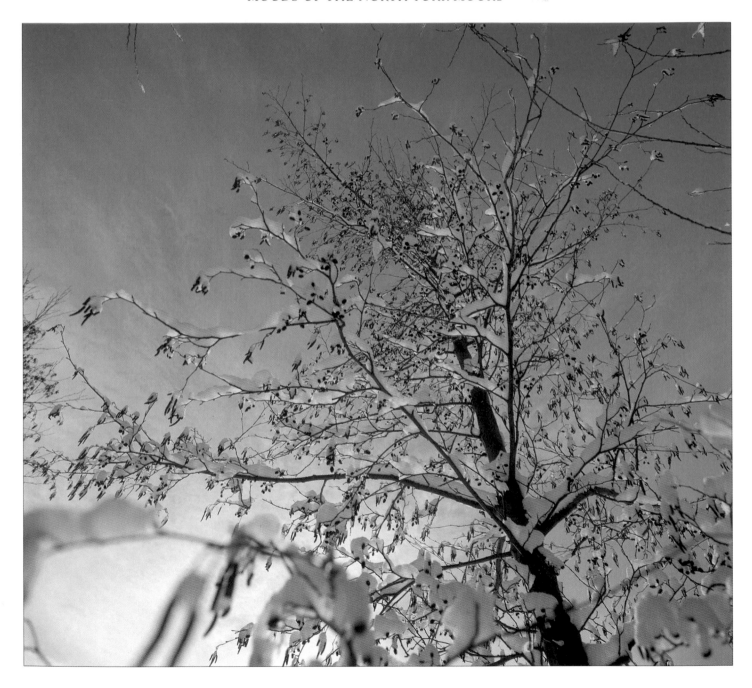

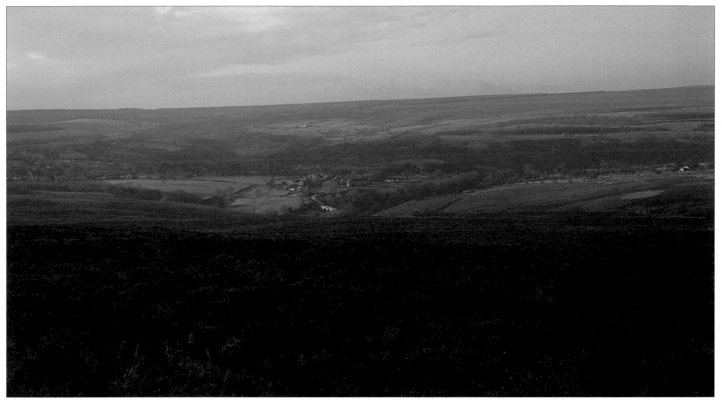

Moorland magnet
*The remote village of Goathland, set in a green oasis amidst wide remote moors,
has always been a honey-pot for visitors. Since the television series* Heartbeat *has been
filmed here it is now sadly overwhelmed on many occasions.*

Opposite: Winter grips the countryside
*The alder, seen here after a snowstorm, is the natural waterside tree of the moorland
valley rivers and streams. Its seeds are a favourite food for flocks of siskins.*

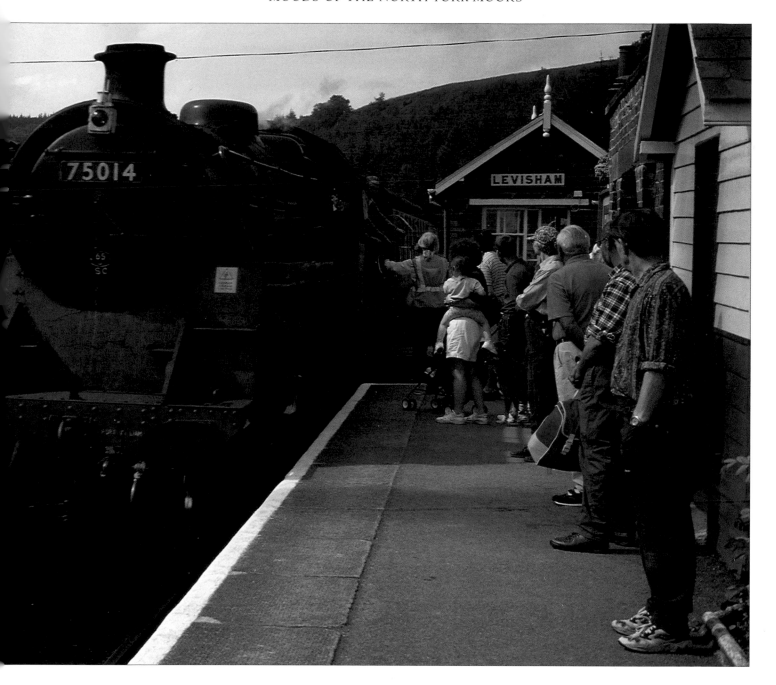

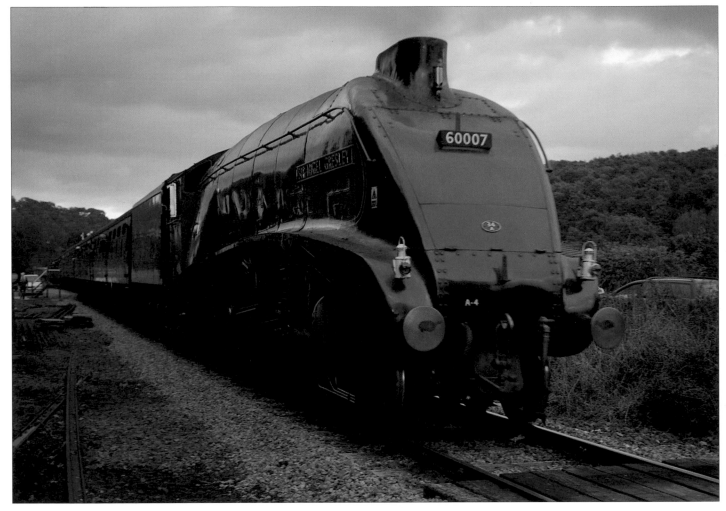

An ultimate design
'Sir Nigel Gresley,' an A4 Pacific and perhaps the most beautiful steam locomotive design ever,
hauls the last train into Pickering in fading light.

Previous pages: Pure nostalgia
They say that steam trains draw out the boy in the man. But judging by the wide affection for these glistening, hissing,
oily, clanky and uniquely smelly living pieces of metal it is clear that their constituency of support is a far from narrow one.

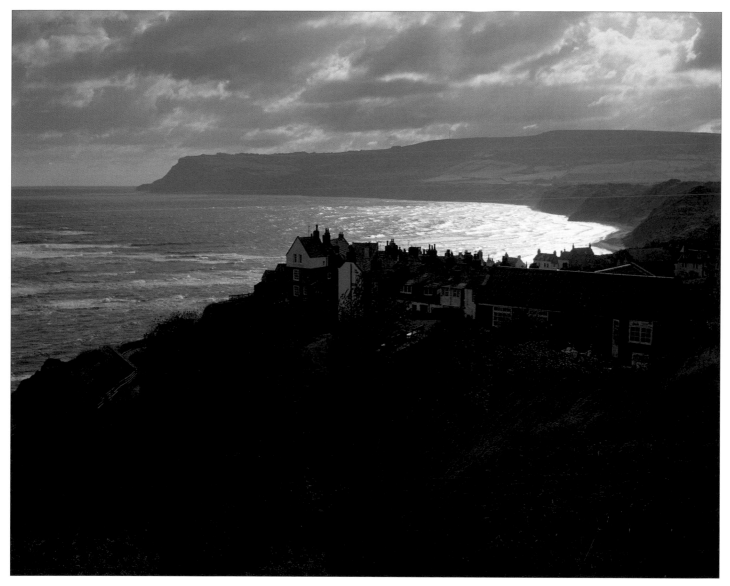

Coastal delight

*No visit to the moors is complete without experiencing Robin Hood's Bay,
particularly out of season when you may well have the village largely to yourself.*

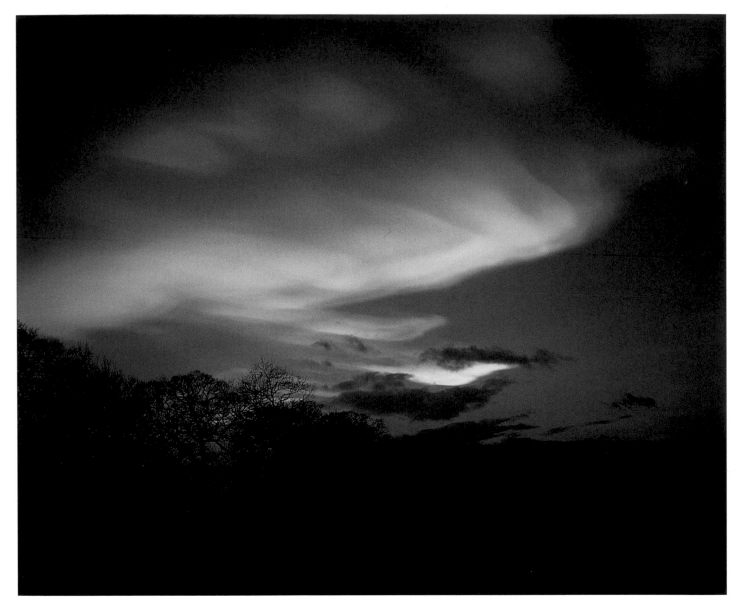

Once-in-a-lifetime skies
*Enjoying the National Park is also about the vast, ever-changing sky, in which these rare
nacreous or mother-of-pearl clouds provided a unique experience in February, 1996.*

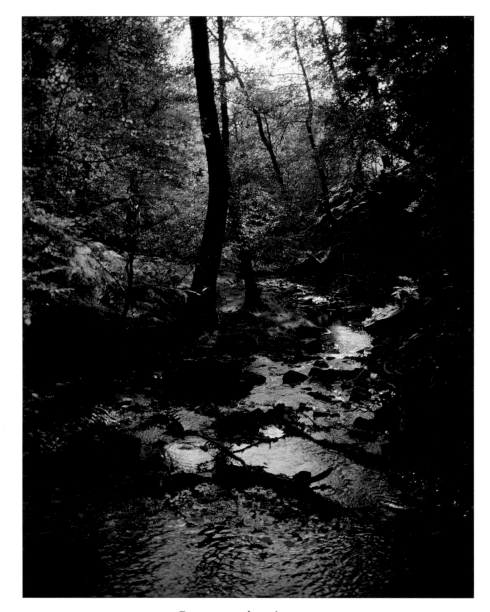

Remote road to the west
*The moor road from Helmsley to Osmotherley wends through attractive farmland,
across open moors and dips through the wooded valley of the infant River Rye.*

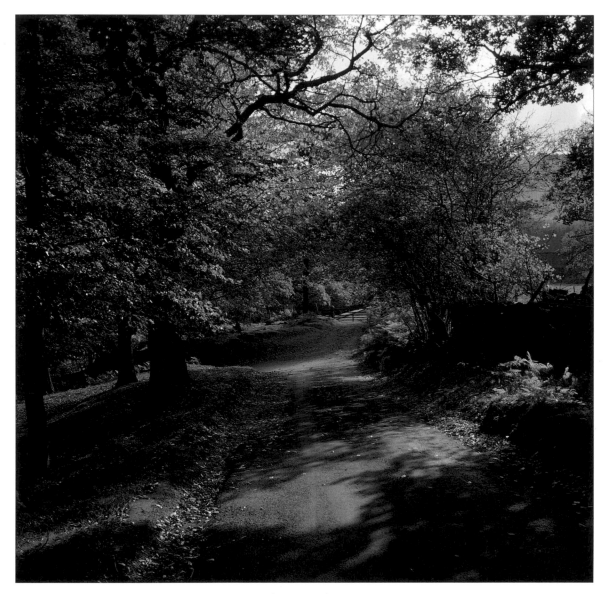

Autumn riot
Breathtaking colours form a tunnel in Hazel Head Woods below Hawnby Moor.

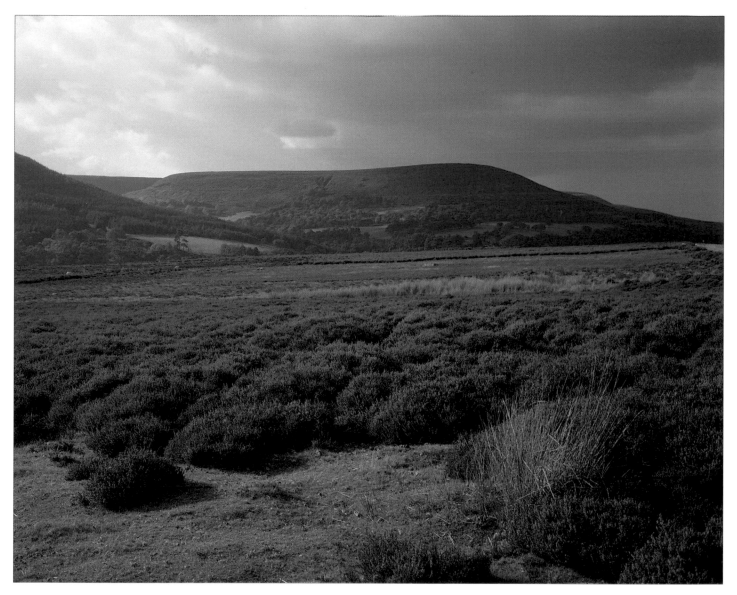

An exhilarating walk

Arching round the moors, the Cleveland Way follows a distinct escarpment for much of its route, but below Black Hambleton
it crosses lower land at Thimbleby Moor before striking north again onto the highest ground.

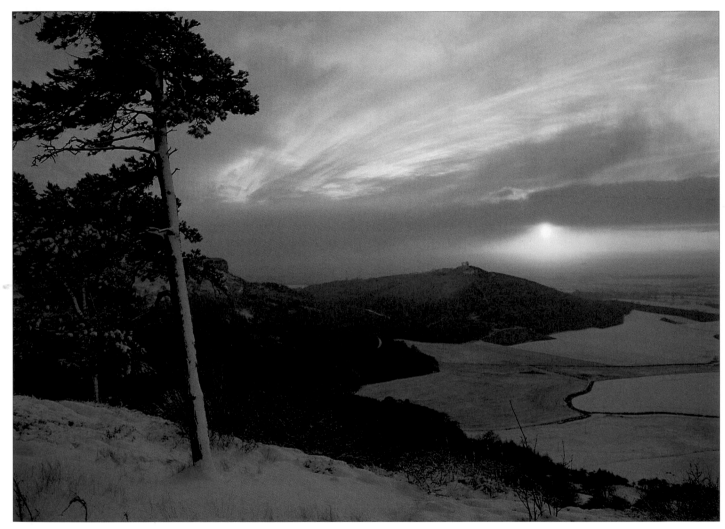

A breathtaking view
A winter sunset embraces Sutton Bank from which on a clear day a 90-mile view can be experienced.

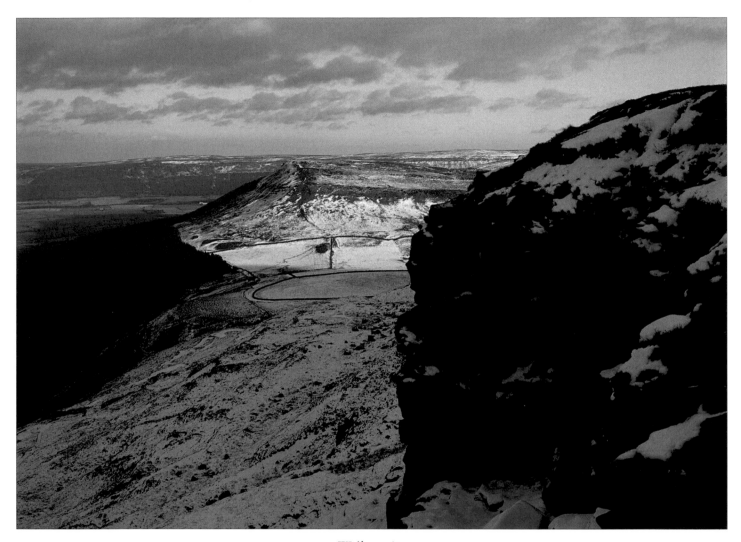

Walks unite
Along the Cleveland Hills, the Cleveland Way unites for several miles with the renowned Coast to Coast cross-country walk.

Middlesbrough's 'mountains'

Snow 'ices' the tree-tops in forestry plantations below the Cleveland Way at Clay Bank car park on the Helmesley to Stokesley Road, with Roseberry Topping and Easby Moor in the distance.

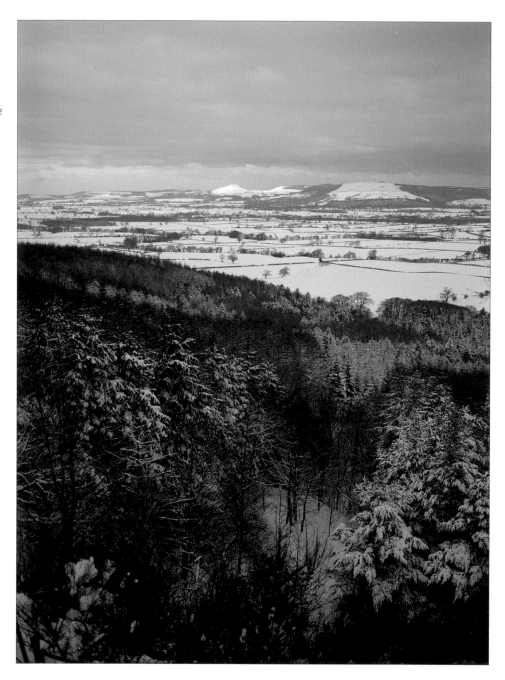

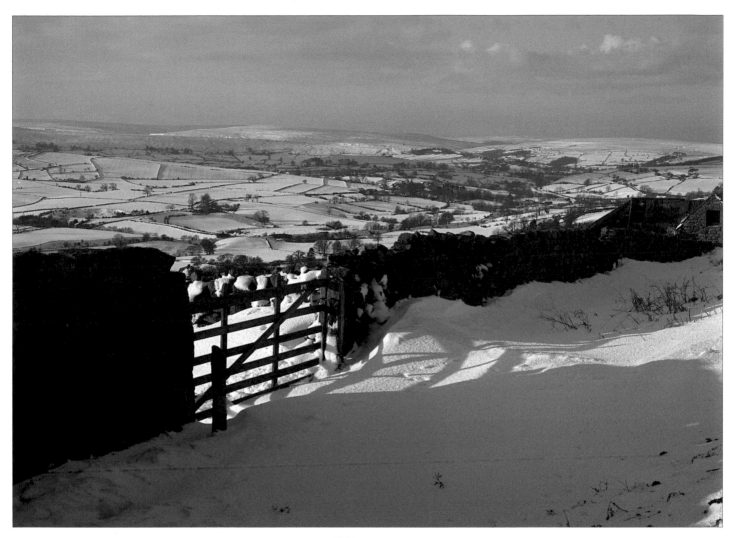

Winter way
*In deep winter, the exposed high moors can be dangerous, but a winter walk down the
Esk Valley Way can still provide a challenge in less exposed countryside.*

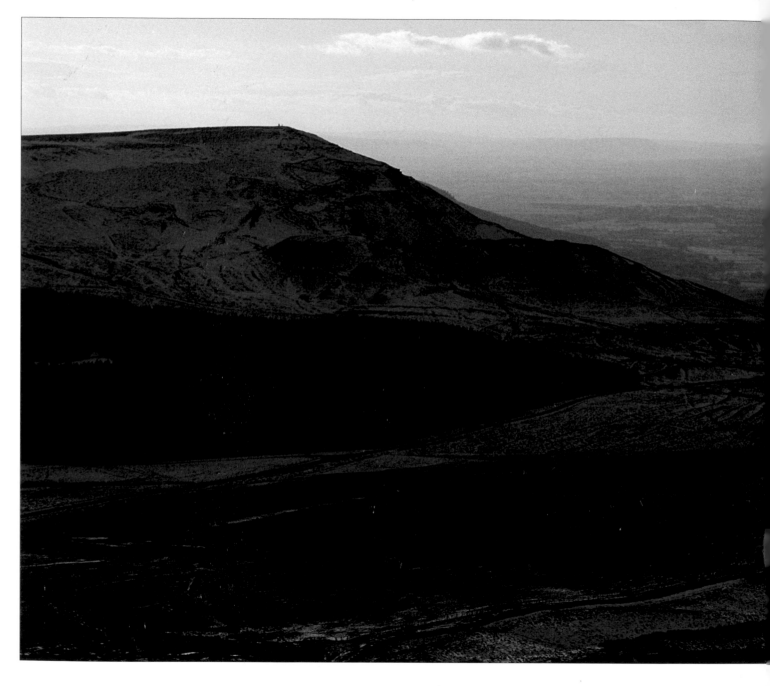

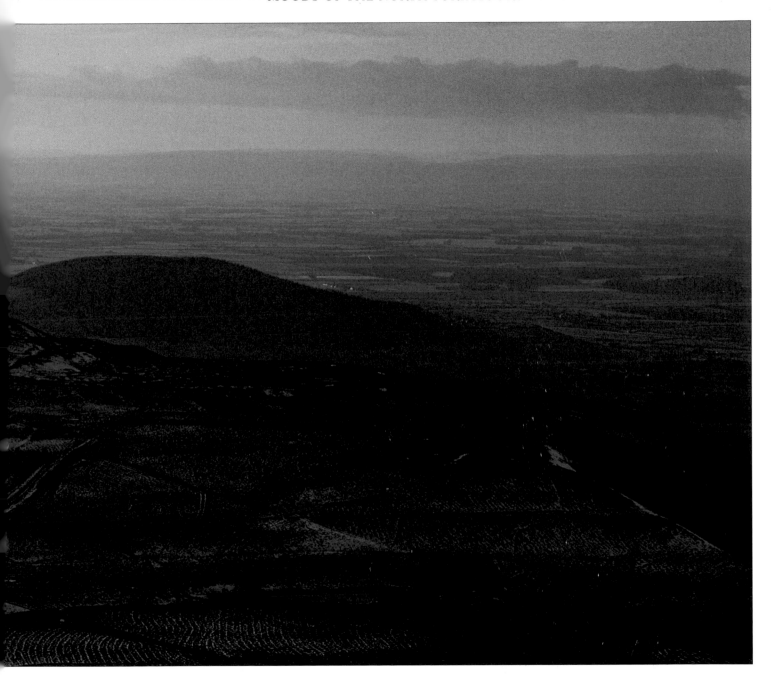

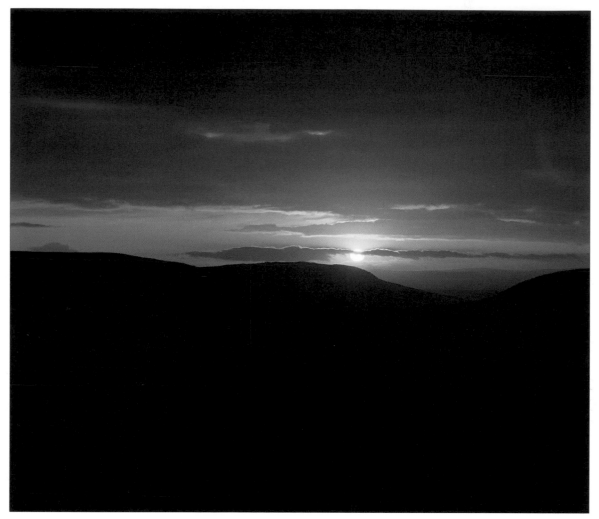

Midwinter sunset
The end of a short winter's day.

Previous pages: A world apart
Up here in the moors it feels a world apart, very definitely separate from the Vales of Pickering,
York and Mowbray and the realities of everyday life in our towns and cities beyond.